The Conservation
and Restoration
of Paintings

T0041054

The Conservation and Restoration of Paintings

An Introduction

JOHN CLIFTON

McFarland & Company, Inc., Publishers

Jefferson, North Carolina, and London

The present work is a reprint of the library bound edition of
The Conservation and Restoration of Paintings: An Intro-
duction, first published in 1988 by McFarland.

LIBRARY OF CONGRESS CATALOGUING-IN-PUBLICATION DATA

Clifton, John, 1915–
 The conservation and restoration of paintings : an introduction /
John Clifton.
 p. cm.
 Includes bibliographical references and index.
 ISBN 978-0-7864-7381-6
 softcover : acid free paper ∞

 1. Painting — Conservation and restoration. I. Title.
ND1650.C5 2012
751.6'2 88-42510

BRITISH LIBRARY CATALOGUING DATA ARE AVAILABLE

Front cover images: iStockphoto/Thinkstock

Manufactured in the United States of America

McFarland & Company, Inc., Publishers
 Box 611, Jefferson, North Carolina 28640
 www.mcfarlandpub.com

Preface

This book is intended not only for those actively engaged in the practice of conservation — amateur or professional — but also for art collectors; owners of art shops, galleries and antique shops; and all who are concerned with the care and preservation of paintings.

My main purpose in assembling these notes was to bring to the attention of the owners of paintings the techniques of preservation and conservation, and to provide a basic technology and a summary of the information available. My other intention was to point out some problems which may be met by people who care about their prints, watercolors and oil paintings, and those who want to venture into collecting art, especially paintings.

This summary is based upon my restoration work with over fourteen hundred paintings and is merely an introduction to what may occur in the life of a painting.

Persons purchasing a painting must have a basic knowledge of its construction. The artistic aspects — beauty, form, composition — are a matter of individual taste, and no other person can easily advise whether to buy. The condition of the painting, however, can be firmly established by those with the necessary knowledge.

These notes are so organized that the reader will be introduced to the construction and execution of paintings, materials used, deterioration, repair, conservation and the prevention of further disintegration. The terminology used should be familiar to readers on both sides of the Atlantic, and a full glossary is included.

La Jolla, California *Rudgwick, West Sussex*

Contents

1. The Restorer's Profession

Restoration is not a licensed profession, and there is no law to prohibit anyone from starting and carrying on as a restorer. However, as this particular vocation embodies a fairly small group of people and is not highly rewarding financially, the general competence amongst the majority of restorers is high.

The Restorer

Let us briefly examine the following: Who is the restorer and what does he do?

In the past most of the work involving repair and renovation of paintings was in the hands of artist painters, and usually relegated to their apprentices. The work of restoration was considered below the dignity of a master artist.

Around 1950 a number of universities in Europe and the United States introduced courses which covered the restoration of art, and at present a number of universities have introduced a four-year seminar dealing exclusively with the conservation and restoration of objects of art. Thus there is a new breed entering this profession, well educated, well trained and dedicated.

So where are these bright young people? Traveling around, one can find a few names in the Yellow Pages Telephone Directory in major towns, and if one asks how long they have been in business, the usual answer is thirty to forty years. The university-

1

trained restorers, it seems, occupy positions in the management of museums and galleries or act as consultants.

Restoration of a painting involves the removal of varnish, removal of the canvas from the stretcher in the case of a dirty and very fragile painting, patching up and filling cracks in the canvas, cleaning it, cleaning and gluing the broken stretcher, repairing the frame which may involve making new moulds for casts of decorative moulding, inpainting missing parts of the painting, affixing eye hooks and picture wire to the frame, and writing examination and restoration reports. All this we have to do, the old-timers.

In the nineteenth century, training in restoration was provided and supervised by a master craftsman; without such training no work was available. Today, the restorer has to be an expert in art, a craftsman of high integrity, and have the knowledge and experience required by this profession. Ideally, he should be a well-educated person, possessing sound judgment, frank and rational, projecting confidence and authority. The restorer needs to have a knowledge of works of art, materials, chemistry, physics, carpentry and painting. Experience as a collector and antiquarian is invaluable. A practical approach and an ability to apply his background during working hours contribute to the qualifications of the restorer.

In the distant past, art conservation was largely a hit-or-miss, back-room affair, left mostly to free-lance practitioners who followed their own methods in repairing damaged or worn works. However, a number of factors, including the soaring prices of paintings and worldwide concern over the disintegration of art, have focused unprecedented attention on the art of conservation and restoration.

Ethics in Restoration

A typical business call from a person seeking advice might take this form: "I have a painting, left to me by my Grandmother, which needs cleaning. Can you do this for me quickly?"

Upon examination of the object of art one might find the gold-

leafed frame has been badly abused, with half of its ornamental moulding missing; the stretcher has broken tongues in each of the corners; the canvas, stored in an attic during the last forty years, has been exposed to rain water, humidity, heat and frost, and now large areas of paint are flaking off; and there are about five holes in the canvas and one L-shaped five-inch tear in the middle of the canvas.

The extent of this damage has to be pointed out before any work is undertaken because most of it has probably not been noticed by the owner. Retouches, repairs and incompetent previous renovation also have to be assessed and explained. The restorer must specify that only essential repairs and inpainting will be undertaken, and that no improvements, falsification, alterations, or changes in the paintings or its composition will be performed.

One of the principles in restoration is that the restorer does not make the painting more accomplished than it was originally; as much as possible of the primary structure, composition and original color must be retained.

Documentation

The restorer's work should be documented as follows:

1. description of the condition of the object to be restored
2. outline of the proposed work
3. particulars of the painting and frame
4. methods and materials to be used during restoration
5. problems encountered during restoration
6. cost estimate
7. insurance

The condition of the object left at the restorer's studio should be described in detail before any work is undertaken. If possible, color photographs of the front and the back of the painting should be taken. This document should be formal and legal and include the date, name of the studio, signature of the restorer and signature of a witness or the owner of the painting.

The outline of the proposed work should cover all details connected with the proposed restoration, including an estimate of time required to perform each operation.

The particulars of the painting should include the *frame* — a detailed description of the style, finish, composition, base, and any other important features; the *stretcher* — the measurements, type, style, material; the *canvas* — the place of origin and approximate year of manufacture as well as a description of the material; the *paint* — basic ingredients, medium; the *finish* — description of varnish or any other medium applied; and the *composition* — school, period, date of painting, painter's name, subject matter, brush strokes.

The method and materials section should encompass a very short description of the restoration technique which will be used, as well as a summary of material used during restoration, such as patching and mending compounds, inpaint and varnish details. If a secondary support is required, the restorer should identify the canvas used and the fusing mixture, as well as the technique of fusing.

The final report should include observations and findings made while removing varnish, previous inpainting, and the canvas from the stretcher.

The cost estimate should include materials, labor, travel and other expenses. The restorer will usually present this to the customer as a lump sum. The cost estimate should also include an approximate date of work completion.

One important question, when paintings are left for restoration and conservation work, is what protection is offered in the event of fire or theft. Generally insurance companies will not provide coverage for individual art objects left on the restorer's premises. This may vary from one area to another, but it is a subject of great importance and should be discussed in detail with the owner of the painting. A formal, written agreement should be drawn up before any work of art is accepted.

The Restorer's Studio

Many of the following observations about the restorer's studio apply to other art studios also. Any area where works of art are

undertaken requires three elements: space, light and cleanliness. All work connected with the creation of paintings is affected by how well the work area is illuminated, how clean it is, and how the work is displayed.

Direct light is used for general work in the studio, and there should be small lamps scattered around the area. Ceiling light provides general illumination, while a powerful diffused light directly above the easel or work bench is used during inpainting, touching up or varnishing.

Dust is a most troublesome factor in the studio because it is almost uncontrollable. Air conditioning and air cleaning will not eliminate it, and unless the studio is fully pressurized, dust will settle on all exposed surfaces. Cleaning the studio with dusters, brooms or vacuum cleaners will only disturb and stimulate the dust layer to break away from surfaces and circulate in the air. The only way that a vacuum cleaner can be used is with a long suction hose so that the main unit with filtering bag remains outside the studio while the hose with the intake brush is operated inside.

The general studio area usually consists of two sections, a studio and a workshop. The studio is used mainly for inpainting, surface cleaning and any other light work where a minimum of dust will be created or disturbed. Some of this area is used for the temporary storage of paintings requiring drying out and varnishing.

Ideally, a studio has a high ceiling so that light—artificial, or reflected sunlight—comes from well above, which reduces shadows. A window curtain provides a means of eliminating daylight when artificial light is used. The ceiling light can consist of several four-foot fluorescent white tubes with efficient diffusers. The studio walls should be of a natural grey or any other neutral, warm color.

The workshop area is used for general storage of painting supplies and for heavier work such as the removal of paintings from frames and stretchers, carpentry, frame and stretcher cleaning and mending. A sprayer-compressor, vacuum pump, woodworking tools and a workbench are all parts of the general workshop.

Tools

The studio of a restorer who attends mainly to the general public must be fairly well equipped with basic tools of the trade.

These tools will include black fluorescent and infrared lights, various magnifiers and special hand tools. Highly sophisticated laboratory equipment is very limited, and some of the expensive and complicated instruments can be operated only by factory-trained experts. The monthly turnover of paintings in a one- or two-man operation is much too small to justify the cost of laboratory equipment.

This of course introduces the question of how many paintings requiring restoration should be exposed to a full examination. In my opinion, every one of them. How many customers can afford such an expenditure is a different matter. Most owners of paintings are interested in having a clean, bright and well-preserved painting, and are not necessarily interested in the composition of paint or varnish, thickness of coating, methods of restoration or x-ray pictures. Museums, on the other hand, are interested in minute details of the painting, irrespective of the cost of such an investigation or the time spent on research.

Storage

A suitable storage area does present a slight problem for the restorer. Apart from the storage of paintings on stretchers, there are always paintings on cardboard and paper; there are frames, glass, ply and wood supports, sheets and rolls of paper. All of these things should be stored in a dust-free area with sufficient air circulation.

Restored paintings remaining in the studio should be protected by loose sheets of paper to prevent dust settling on the varnished surface, and accidental damage.

Oil paintings are stored in a vertical position, side by side, separated by a four-inch gap. Those paintings awaiting restoration should be removed from their frames, vacuum-cleaned and fumigated.

2. Construction of Paintings

Before commencing any discussion relating to conservation and restoration of a painting, we must arrive at a very basic understanding of its composition and design.

Any man-made structure encompasses certain elements, and in the case of a painting they are *frame, stretcher, support, ground, paint* and *varnish* (Fig.1). Conservation will involve dealing with each of these elements, and a good understanding of them will improve and ease reconstruction and restoration.

Support

The support is the structure which carries all of the painted surface, namely *ground, paint* and *varnish*. The quality of the support determines how long the painting will survive the environment.

The most common supports are wood, paper and fabric. Glass, copper, zinc, ivory, porcelain, leather and plaster have also been used.

Wood, fabric and paper are composed of cellulose. The wood particles or fibers remain in the original state and form panels for painting. However, with fabric and paper the fibers have been removed from the original state or position of growth and, by means of various chemical and mechanical processes, have been twisted, woven or felted into a new composition.

7

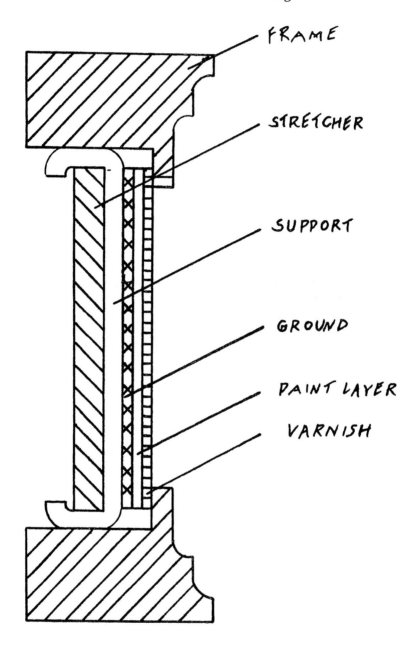

Fig. 1. Construction of a painting.

Wooden Support

Before and during the Middle Ages wood was the most commonly used support for paintings. As a material it is tough, resistant to heat, abrasion and pressure, and easily workable with simple hand tools.

The main drawbacks of wood are its tendencies to warp, split, absorb water and be easily infested with insects. However, when properly treated with preservatives and kept in a controlled environment, wood panels can last a long time.

When using wooden panel as a support, the artist should choose a dry, well-seasoned wood, and an oak cradle should be attached to the back of the panel before any painting is undertaken, to prevent and arrest warping and splitting which may occur due to turpentine and oils being absorbed by the panel and then gradually drying out. Both sides of a panel must be sealed to prevent water absorption.

The following list identifies the kind of panels used in the past:

Cedar of Lebanon (Greek School)
Chestnut (European Schools, mostly Italian)
Fir (German and Flemish Schools)
Linden (German, Flemish and Italian)
Mahogany (Flemish and English)
Oak (Flemish and English)
Pine, soft and hard (European)
Poplar (Italian and French)
Walnut (European)
Fruitwood (French)

Paper Support

Paper used for artwork can be found in several forms: *handmade paper,* which is teased from cotton or linen rags; *mulberry tree fiber paper,* which is pounded and matted into sheets; *mould-made and pressed paper* for watercolors and etchings; and *machine-made paper,* used for newsprint, brown bags, and other inexpensive products, often referred to as sulphite pulp.

Two different forms of paper are known as *rag paper* and *pulp*

paper. Rag paper is made from cotton or linen rags, and the fibers are intertwined in an irregular mass. First the rags are softened and macerated until the separate fibers are teased out, and they are then floated in a solution and felted into a sheet. Rag paper is usually handpressed. This paper can be turned into Academy Board, which is made by machine pressing of the pasteboard, giving a rough texture on one side.

Pulp paper is made of wood fibers which, as a rule, are separated in a chemical bath. The ground-up wood fibers constitute newsprint and cardboard, the latter of which is made of laminated layers pressed together.

Pulp paper was used extensively in Europe towards the end of the eighteenth and the beginning of the nineteenth century, for the making of sketches, watercolors, prints and lithographs. Tragically for the art world, the results of this usage have been discoloration, mould growth and fading.

Pulp paper also contains arsenic in various concentrations. Blue skies painted on this paper turn green in time, and green trees turn into dark browns.

One must remember that paper maintains an equilibrium with its environment and readily absorbs chemicals and moisture from the air. The absorption of moisture provides a perfect mechanism for the conversion of sulfur dioxide, one of the major impurities in air, to sulfuric acid. When such acid forms in paper it will react continually with the paper's cellulose, causing the paper to disintegrate.

Composition Board

Bristol drawing board, medium or high surface finish, is manufactured in various sheet sizes from rugged 100 percent cotton fiber. This board is usually well made and can take repeated erasures and reworking without feathering, and is designed to take almost any technique of painting; it will support the most delicate line work without distortion.

Illustration board, a "high press" type, has a high rag content and is used primarily for pen and ink and airbrush work. The "cold

press" type is similar in manufacture, but its surface has just enough tooth for perfect wash and watercolor work.

All of these boards are obtainable in various grades from 1 to 28 ply.

Canvas board is an already sized and primed canvas which is firmly cemented to an extra heavy non-warping board and turned in on the edges and corners. This board is one of the best supports available on the market for oil and casein painting and offers good stability, durability and ease of storing and handling.

Fabric

The word *fabric* specifies a cloth made by weaving, knitting or felting fibers, but does not identify the source of the material. Fabric can be composed of animal, vegetable or man-made fibers.

Under fabric made from animal sources we can include silk and animal hair; under vegetable, fibers from plant stems and vegetable hairs; man-made fibers include nylon, rayon and synthetic materials.

One of the earliest supports devised for paintings was silk, and it is still used throughout Asia, Europe and the United States. Although it is very fragile, when well supported silk may last for centuries.

The dictionary identifies *canvas* as a closely woven, heavy cloth of hemp, flax or cotton. Cotton canvas is woven from thread spun from the soft, white hairs attached to the seeds of malvaceous plants. Linen canvas is woven from thread made from the fibers of the flax plant.

Canvas has a tendency to absorb a lot of ground body and underpaint. As the tension of the canvas varies according to the atmospheric conditions it expands and contracts. This movement causes no problem for several months after a painting has been finished as the layers of ground and paint remain flexible and can move with the canvas. However, when absolutely dry the paint becomes rigid and will crack when subjected to this expansion and contraction of the canvas. Another cause of cracking of the paint is that the ground material penetrates deep into the canvas and has a tendency to swell at high humidity, thus lifting and cracking the paint and varnish.

Metal Support

Although quite common in the past, metal supports have been completely abandoned now and have been replaced by the use of composition boards, laminated wood and plastic boards. Metals used in the past include copper, usually bitten or rolled into sheets, zinc and tin, and aluminum.

Hard aluminum is frequently used today as a secondary support for canvas as it offers a very stable material with a very low co-efficient of expansion; usually it is attached to the painting with wax, and it can be removed, safely and easily, with heat. For large paintings, thin aluminum sheets bonded with aluminum honeycomb core to fiberglass skins provide a solid and rigid panel. The composition of these panels provides a support of very light weight, with extreme resistance to warping, and high dimensional stability.

Ground

The ground is a smooth, flat coating, very thinly applied over the support. It is prepared from two ingredients, *powder* and *binder*.

For paper supports, the ground is made of chalk mixed with natural adhesive. A linseed oil, lead and gypsum combination is used when pastel and chalk drawings are executed on paper. For canvas, white pigments, consisting of white lead or zinc or titanium, are mixed with chalk and oil and spread over the surface; this mixture is called *gesso*.

Older canvases used to be sized with rabbit-skin adhesive, but the main problems with this kind of coating are mould growth and reaction to changes in humidity. This reaction results in shrinking and expansion.

Sometimes the ground put on the canvas does not accept the oil paint which is applied; the paint does not stick to the ground but rolls off, forming bubbles and beads, as though the paint were applied over a wet and slippery surface. To improve the painting

action, pumice, chalk and gypsum can be scrubbed over the surface. Another method is to rub the surface with a sliced onion or potato.

When the ground of an old oil painting is very shiny and smooth, gentle wiping with diluted alcohol and a very light application of a retouch varnish will help with the application of the new paint.

Tempera paintings, when executed on solid panels such as Masonite, wood or metal, necessitate irregular roughening of the surface, in all directions. This roughening will provide a greater retention of the size, priming and ground.

Surface Coatings

Varnish

Varnish is a solution of resinous matter forming a clear, limpid fluid capable of hardening without losing its transparency. In application, varnish must be tender and, in a manner, soft. It should yield to the movement of the supports such as wood or canvas. As we have seen, such movement is usually caused by changes in humidity, temperature and pressure.

The main ingredients of varnish are *rosin* and *alcohol*. Rosin comes in two forms, hard and soft. Hard rosins are copal and amber. Soft rosins are juniper gum, mastic and damar. Elastic soft rosins are benzoin, elemi, anime and turpentine.

The terms *resin* and *rosin* have created a lot of confusion. The word rosin was originally used to describe such synthetic substances as had the properties of resin, but these days it is used in a very much wider sense. This usage has resulted in chaos in the trade names of various products.

Resin is a vegetable product, an organic polymer often referred to as "true, natural resin"; it is obtained directly from secretion and disintegration of the bark of many varieties of trees and shrubs.

The best-known resins are now called *rosin* and *balsam* and are obtained from coniferous trees. Of more remote origin are *damar*, *mastic, sandarac* and *copal.* Resins are insoluble in water but soluble in alcohol and ether and are fusible and combustible.

Gum rosin is the residue obtained after the distillation of turpentine oil from the oleoresin tapped from living trees. *Wood rosin* is obtained by extraction from pine stumps with naphtha, and distillation. *Tall oil rosin* is a byproduct of the fractionation of tall oil.

Rosin consists of about 90 percent resin acids and 10 percent neutral materials. It oxidizes readily in air, becoming harder and darker in color, and it softens at about 80–90°C; its use is in pressure-sensitive adhesives, mastics, varnishes, paper sizing, printing inks, polishes and polyesters.

Another group of resins is the *synthetic resin group*. This is a heterogeneous group of compounds produced synthetically from simpler compounds by polymerization or condensation. The physical properties of this group are similar to the natural resins, but the group is different chemically and is referred to as *plastics.*

Damar varnish, which is a soft resin, dries rapidly and bonds well with oil paint. It can be used as a painting medium, glaze or final picture varnish.

Mastic varnish is used only as a final varnish on paintings. The mastic tears can be combined with turpentine, benzene, methyl alcohol or ethyl alcohol to form varnish.

Copal varnish is produced from copal resins or amber, benzene and turpentine; when used as a varnish this yields an extremely hard surface. It can also be used as a painting medium or, when thinned many times with benzene, as a fixative.

These varnishes are often combined with stand oil and toluene to accelerate drying. When combined with alcohol and beeswax they produce a soft finish. Raw linseed oil can be added to reduce the brittle quality of soft resins without greatly lengthening their drying time. The alcohol used in varnish production is obtained by fermentation of a sugar or a starch converted into sugar.

Varnish for water-based paints is based on leaf gelatine solution or hide adhesive solution. In the past, these two varnishes were applied over tempera emulsion paintings and gouache, to retain the dull finish.

Shellac varnish based on alcohol solution is used mainly to isolate layers of gum, glue and oil paint. The dry coat of shellac rejects water and is used extensively as varnish to seal water-soluble color sketches.

Synthetic Varnish

Synthetic resins, such as acrylics and vinyls, which are suspended in water to form an emulsion, can also be dissolved in appropriate solvents to form plastic varnishes.

There are two varnish finishes available, *gloss* and *matt,* and they are normally water soluble. When applied to a surface, acrylic varnish forms a permanent bond with the paint beneath; once it has been put on, it is there to stay.

Retouch Varnish

One of the varnishes used during restoration work is *retouch varnish.* This can be applied with a soft brush or sprayed on, and should be extra thin and limpid and should dry without a tack within minutes. When prepared from the best-grade materials retouch varnish is colorless.

The main reasons for using retouch varnish are to bring out sunken-in colors and to protect against dirt. This varnish should be applied whenever a paint surface appears dull. However, unless the underlying paint is thoroughly dry, this varnish will disintegrate because the strong rate of oxidation of the still-wet paint will destroy the cohesion of the varnish film.

Wax Coating

Wax diluted in alcohol or turpentine produces a long-lasting surface coating. Although standard beeswax is fairly soft, it has a tendency to harden while aging.

Carnauba wax is a hard-setting wax and is used mostly on panel paintings so that a degree of rubbing with one's palm will not spoil the painting.

Stretcher

Stretchers are used to hold up canvas, wood, paper or cardboard supports. There are two stretcher designs available, *fixed* and *adjustable*. The fixed stretcher consists of four wooden slats joined permanently at the corners. The adjustable stretcher is made from four wooden slats with slotted corners, where wooden wedges or pegs are inserted. The canvas, secured on the edges of the stretcher slats, can be stretched by hammering in all wedges. The damage most often observed consists of warping, breakage and damage to corner slots.

Any stretcher repair necessitates the removal of the painting from the stretcher. This can be a tedious operation requiring special tools for the removal of nails and tacks to avoid damage to the canvas. When disassembled, the stretcher and all its parts should be fumigated and impregnated with a wood sealer.

Frames

The main purpose of a picture frame is to offer some protection to the painting, and at the same time to give it a greater depth and dimension. In a suitable frame a large picture can appear fairly small, and a small one, inserted in a large, heavily ornamental frame, can look relatively large.

Some frames are ornamented with heavy gilt carvings of wood, plaster or papier-mache. These carvings are attached to the frame structure by means of nails, screws or glue.

Most damage to frames is due to improper handling, scuffing during removal or moisture penetration resulting in glue joints opening. A lot of damage is due to the incorrect placement of a painting in a frame. The use of nails and hammering increases the risks of frame and even of picture damage.

However, the most visual damage which can be observed is produced by dust and dirt which accumulates in all cracks, crevices, grooves and slots, in the front and at the back of frames.

The front of the frame can be cleaned with the help of a soft brush and antistatic cloth duster. The back, after cleaning, should be protected with a thick laminated cardboard, with openings for air circulation, one round opening at the top and another at the bottom of the cardboard. The idea behind this is to keep dust and dirt away from the back of the painting and also to offer some protection to the support and frame structure.

3. Technique of Painting

Although there are many books dealing with "How to Paint" which describe and analyze technique, it is essential here to consider painting materials and methods from the point of view of the restorer.

Practically every painting has been executed with one particular technique, and unless the basis of this technique is known and understood, it would be unrealistic to undertake repair of any sustained damage. Also, every painting involves a different combination and composition of paints which, combined with the technique used, produce the required effect. Of course the total visual effect depends upon color, tint, tone and shade.

We can undertake no discussion of painting technique without first understanding the phenomenon called color. Color in painting is the general effect of all the hues entering into the composition of a picture.

The usual order of color can be presented in the form of a diagram (see Fig. 2, page 19). As experienced through our eyes and brains there are seven forms. The first, *pure color,* is any and all colors in the spectrum; then there is *white* and there is *black.* In combination pure color and white form *tint* (such as pink). while pure color and black form *shade.* White and black form *gray.* It can be added that pure color with white and black forms muted *tones* such as beige. The chart on page 20 shows color composition, or how various colors are formed.

Two basic ingredients constitute the paint proper: the *pigment* and the *binder.*

Pigment materials are many and varied, and their composition

18

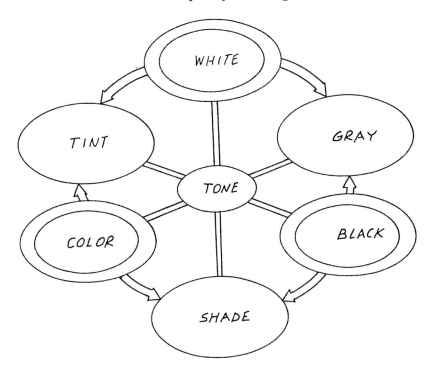

Fig. 2. The seven forms of color.

can be obtained from handbooks dealing with paint. Pigments are classified into two main groups: natural and synthetic. Natural pigments come from mineral and organic materials. From earth sources come yellow ochres; from clay, terre verte; from lapis, ultramarine. Red comes from iron; black from coal. Organic pigments are obtained from animal sources (indian yellow, carmine and sepia) and from vegetable compounds (madders, indigo and sap green). Synthetic pigments include white lead, cobalt blue, viridian, cadmium and prussian blue. Other substances used in the preparation of pigments are dyes such as old madder and alizarin crimson.

The properties of pigments are *color,* where each tiny particle is a transparent body which colors light by selective absorption; *transparency,* which is very important in glazes and forming shadows; *working property,* by the choice of a suitable medium;

STRONG DARKS	ultramarine blue plus cadmium red deep; ultramarine blue plus cadmium red light; ultramarine blue plus cadmium red orange
LIGHT DARKS	cerulean blue plus cadmium red light, plus white, producing pearly gray
LIGHT GREEN	cerulean blue plus cadmium yellow pale, or yellow ochre light plus thalo blue
DEEP GREEN	cerulean blue plus burnt sienna
DARK GREEN	ultramarine blue plus cadmium yellow pale; or ultramarine blue plus raw sienna
OLIVE GREEN	ultramarine blue plus cadmium orange plus white
PINK	alizarin crimson plus white
BRILLIANT RED	alizarin crimson plus cadmium red light
WARM COLOR	cadmium yellow pale plus cadmium orange; or yellow ochre plus burnt sienna;
BLACK	ultramarine blue plus cadmium red deep plus cadmium orange
GRAY	cerulean blue plus cadmium red plus white, or cerulean blue plus burnt umber
TAN	as gray, plus orange
BROWN	ultramarine blue plus orange

Color composition

drying power, which depends on oxygen absorption; and *permanence,* which is a function of interaction with light, oxygen, moisture, atmosphere and other pigments.

Dry pigments have to be well ground into a very fine powder before use. If the particles are too coarse, they should be reground in a china mortar with an ordinary hard ceramic pestle.

The binding constituents used in the past were obtainable in several forms, including *inks* — based on animal glue composed of gelatin, bones, tendons and skin; *lacquers* — based on poisonous sap

from Asia; *egg yolk* — in solution with water; *gum arabic* — forming the base of water paints; and *oils* — made from walnuts, poppy seeds and flax seeds. All these substances suffer from deterioration due to aging, and become weak and brittle, opaque and yellowish due to oxidation. Based on my observation, I believe that the binders least affected by aging are lacquer and wax.

It is easy to understand now what chemical reactions and mechanical deformations take place on the canvas, which is itself a very unstable material. Every painting reacts differently to the light, temperature and humidity variations. Impurities of the air will also contribute to chemical changes in the binding solution and varnish.

Watercolor

Watercolor is one of the oldest painting techniques and has been employed since ancient times. Watercolor is a medium composed of finely ground pigments suspended in a water solution of gum arabic. Unfortunately, today there is little or no genuine gum arabic to be had; therefore there is a certain amount of adulteration and falsification of watercolor. As the products prepared and sold for general use are seldom properly and equally gummed, it is advisable to have a quantity of gummed water ready for use while painting, to allow for any deficiency.

Sugar, honey and glycerine, which are sometimes combined in watercolor preparation, should be avoided as additives because they have a tendency to attract insects and also contribute to the growth of mould.

The support for watercolor is usually paper or cardboard.

There are two techniques of watercolor painting: *heavy* and *light*. Heavy technique involves the use of a fairly thick paint mixture, applied to paper in almost the same manner as an oil paint. Light technique uses water paint applied with wide strokes, and parts of the paper are often allowed to show through to provide a reflective base for the transparent color.

Gouache

This is a method of opaque watercolor painting and covers a very wide range of techniques, from quite thin to a rich texture similar to heavy oil painting.

The paint comes ready prepared in tubes or jars under the name *opaque watercolor, tempera color,* or *poster paint.* The work is usually accomplished on heavy paper with grounds of glue or gesso applied in heavy layers.

Artists usually apply vigorous brushwork, a heavy impasto, resulting in cracking and flaking as the glue-bound colors have no ability to withstand contractions and shrinkage during the drying period.

The applied colors dry considerably lighter in tone, which must be taken into account when touching up during restoration.

Gouache paintings are usually varnished, waxed or glazed. The painting medium can be water, egg yolk or emulsified wax.

Tempera

This method involves the application of aqueous paint based on *glue, casein* or *egg* binder.

Glue binder usually consists of any animal glue emulsified with linseed oil, resin or varnish under heat. This mixture provides good strength and permanence when applied as paint to any paper or wood support. To insure easy emulsification, a few drops of household ammonia are added.

Casein binder is composed of white curd from skim milk which is combined with slaked lime and then emulsified. Although this paint was very popular in the 1800s in the United States, it is not recommended for top layer paint application but for underpainting only.

The pure casein should be stirred well into distilled, warm water and a small amount (5 percent) of household ammonia added. For greater binding power, some damar varnish may be added.

When casein is mixed with linseed oil, venice turpentine and turpentine to form a paste, and ground well with pigments, it will form a thoroughly water-resistant paint with a matt finish. This mixture made without pigment, and diluted with turpentine, has been used in the past as a final varnish for oil paintings.

To slow the drying process some copal crystals can be added. To improve water resistance, paraffin should replace ordinary turpentine. Casein mixed with beeswax, water and ammonium carbonate over heat provides an excellent binder for water paint.

Grounds for tempera paintings, when using solid panels such as Masonite, wood or metal, can be in the form of *size* or *priming*. The smooth surface of the support should be roughened in all directions, irregularly, which provides greater retention of the applied size and priming.

The size should be made of hide glue and gelatin and applied to both sides of the surface as well as the edges.

The best formula for priming is to use size as above and add equal portions of zinc oxide and whiting to form a buttery mixture. Damar varnish or stand oil can be added to improve the hardening of the primer. This mixture must be completely stirred and when ready, more warm size added.

At least seven to ten coats of primer should be used. The degree of smoothness required can be obtained by sanding with coarse or fine sandpaper.

Egg Tempera

This medium, extensively used in the Middle Ages, is again becoming popular. Egg tempera is a paint based on a binder composed of egg yolk mixed with water and pigment.

The main characteristic of this paint is its ability to adhere to most support materials. Another chracteristic is the improvement of color, hardness, depth and transparency with time. The difference in appearance between watercolor and egg tempera is the lifelike look of egg tempera colors and their brilliance.

In the past, egg tempera was used in conjunction with oil paints and quite often for the underpainting of pictures. The technique involves a gradual buildup of paint layers with short brush strokes.

Besides being used as an underpainting for oils, egg tempera is used by restorers for overpainting or bringing up portions of a painting. When well diluted with water, it can also simulate water-color effects.

Completed paintings are usually lightly polished with a soft silk rag, waxed or varnished. Care should be taken that the effect intended is not altered as wax and varnish will deepen the tints and tones of the colors, particularly earth tones and blues.

Another good egg-based solution is a mixture of a whole egg, raw linseed oil and a few drops of vinegar. When mixed with pigments this forms a good paint which can be used directly on gesso-covered supports, without any underpainting.

Glair

Glair is egg white beaten into a froth and mixed with water. Mixed with fine, dry pigments, it becomes a good paint which can be used on parchment or paper.

Egg Varnish

Egg varnish consists of a whole egg, broken and stirred into damar varnish or stand oil, with distilled water added. If necessary, this mixture can be strained through loosely woven cheesecloth. It is excellent for use as a final coat on all paints.

The use of cheesecloth for all straining of painting materials is highly recommended.

Synthetic Paints

Synthetic paints are man-made media available in two categories: *acrylic resins* and *polyvinyl acetates*.

The synthetic resins are usually suspended in a water medium; they are basically emulsions and not solutions. In an emulsion, the

resin is present as microscopically fine plastic particles. In a solution, one material is dissolved in another so that a clear, homogeneous mixture is obtained.

Acrylic resin consists of polymer emulsion and pigments, dispersants, wetting agents and antifoaming agents. There are three types of polymer emulsion paints: *acrylic resin-based paints,* which are the most popular type of synthetic artist's paint; *polyvinyl acetate paints,* which were used during the early stages of emulsion-developed paint; and *copolymers,* which utilize a resin made by using two or more different chemicals in forming the resin.

Vinyl acetate resins are produced under the name *Vinylite,* and come in a crystal-like form. Solvents for these paints are acetone and denatured alcohol, with butanol acting as a blending agent. Another possible solvent is methyl isobutyl ketone, but this is a very toxic substance.

When acrylic paints are used, the water contained in the mixture evaporates and the resin crystals and pigments form the desired paint film. These paints can be diluted with water and used with the same technique as watercolors, or they can be applied like oil paints.

In spite of acrylic paints being water-based, soon after application they dry and become impervious to water.

Acrylic resin paints cannot be mixed with turpentine, oils or varnishes.

Oil Paints

The oil medium is based on flax seed, poppy seed or linseed and turpentine. Pigments are added to these oils, producing what we call an oil paint.

The outstanding characteristics of oil paints are that they can be reworked, corrected, scraped off the board and diluted when desired.

The first oil paintings date from the fifteenth century. Although at first oil paint was mostly used indoors because pig-

ments and oil had to be prepared on the palette, the introduction of premixed paints packaged in tubular containers enabled artists to start painting out-of-doors.

Oil painting technique calls for oil paint application over a well-prepared support; the canvas or board used must be furnished with a suitable ground.

The artist can construct layers of color and transparent glazes, or apply the oil paint directly without any underpainting to obtain the desired finish. For underpainting, the paint used should be as lean as possible, meaning that the ratio of pigment to binder should be high. Diluting oil color paints as they come from the tube is not recommended. Rather, white lead, dry pigment should be mixed with the tube color, and solvent used sparingly to make the newly formed paint mixture workable. The white lead pigment will enable formation of a perfect bond between paint and ground.

Before commencing the actual painting, a coat of retouch or an isolating varnish should be applied.

The traditional method of the masters demanded a very precise and methodical construction of a painting, building the desired composition layer by layer; this required weeks, months, and sometimes years to complete, and involved a great deal of dedication. The new technique, however, which allows the use of dryers, permits a painting to be finished in one day.

One must remember that it is not the surface of the painting but the translucency of the paint that produces the desired optical effect. Light passing through the oil paint, reflecting off successive layers of paint held in suspension by the media used, creates a luminous effect. It is impossible to create this effect by an application of a single layer of paint, however good and experienced the artist may be.

An analysis of oil paints used in the past is beyond the scope of this work. There is an abundance of books and publications on paints and varnishes which one can study to obtain more specific information.

Encaustic Paints

This category embodies works of art painted with wax colors fixed with heat, or with any process in which colors are burned in.

Wax colors consist of pigments suspended in hot wax and are applied by brush or knife. These paints exhibit extremely stable behavior and last astonishingly well without discoloration.

The best examples of encaustic painting are found in the art of Herculaneum and Pompeii. Today examples of the technique are rare, as the process is fairly complicated and considered too much trouble.

Painting Medium

Medium is the liquid with which prepared paints or pigments are mixed to ease their application, forming the following mixtures.

Gesso

As a painting medium, gesso, or gelatin solution, produces an extremely clear, transparent protective coat, and dissolves easily for quick preparation; it consists of gelatin and water. Usually this is brushed hot over the panel or fabric, and when the first coat is completely dry, a coat of gesso mixed with whiting is brushed hot over the first.

Starch Solution

This solid carbohydrate dissolved in water gives quick drying protection to paper, fabric, cardboard or wood. It is also used for the preparation of quick-drying paints for sketching.

Synthetic Resin Emulsion

This liquid preparation is used as size both for the support and the painting. Synthetic resin, obtainable in a form of white glue, is diluted with water and brushed on paper, fabric, board or wood.

Encaustic with Beeswax

A mixture of beeswax and turpentine is warmed until all wax is melted, then cooled. The resulting paste is mixed with dry pigments and applied to a panel with a brush or palette knife.

Egg Emulsion

Egg oil emulsion produces a non-dripping paint which permits the finest and most detailed brushwork in a wet oil painting. It usually consists of egg yolk, heavy stand oil and water. Dry pigments are ground into the emulsion.

Pastels

Pastels are made from gelatin-water solution combined with gum tragacanth solution and dry pigments. They are quite often combined with other media, such as gouache, glue paints or synthetic resins.

Damar Varnish

This varnish, combined with raw linseed oil and turpentine, was used as a "fat-over-lean" medium by a number of painters in the eighteenth and nineteenth centuries; it was mixed with dry pigments and later with oil paints out of the tube.

Damar varnish has also been used as an instant paint when it was combined with heavy stand oil, toluene and alcohol and dry

pigments. This combination was used mainly as a glazing and touch-up medium.

Many combinations could be used, depending on the painting technique chosen and the degree of drying required. Venice turpentine, stand oil, toluene and alcohol provide control of viscosity and thickness.

Mastic Varnish

Mastic resin prepared as a varnish and mixed with Venice turpentine displays clarity and non-yellowing characteristics. This particular medium contains no oil and is generally used as a final layer of paint, glaze of varnish.

Copal Medium

Copal resin makes oil paint stay in place, eliminating the tendency to sag or run. This medium produces very hard layers of paint when combined with heavy stand oil, turpentine and wax.

Wax

Some painters in the past employed beeswax in combination with damar varnish, sun-thickened linseed oil, and turpentine, to obtain an oil paint of a thick, buttery but light consistency.

The amount of wax used will control the gloss of the finish. For very high gloss and a strong protective final coat, a combination of Venice turpentine and raw linseed oil produces good results.

Glaze

Glazing means covering a painted surface with a thin layer of transparent color in order to modify the tone. In general, glazing completes the optical effects of the painting by enriching the underlying paint.

Certain rules of glazing guide the artist:

•It is always advisable to glaze a warm color over a cool one, and vice versa.

•The color value between glaze and underpaint should not vary too much as this would make the painting look uneven. The color should be mixed only one value darker than the paint to be covered.

•Any glazing should be performed in daylight as some glazes are hard to see under artificial light.

Several media have been used to supply a suitable agent for glazing. A solution of damar resin and turpentine has been utilized for the final applicaton of transparent color; this solution has the advantage of bonding well with the final picture varnish. Stand oil combined with damar varnish and turpentine was used in the past. Damar balsam, which is a mixture of damar varnish, sun-thickened linseed oil and Venice turpentine, produces a brilliant gloss finish. Dull and matt finishes can be produced by mixing mastic varnish with wax and turpentine.

For glazing gum, glue and casein paintings, damar varnish combined with mastic varnish and wax can be used. To prolong the drying of any glazing medium, some wax should be added.

Oil Media

The most popular medium for painting has been and still is based on a combination of various oils such as linseed oil (raw or refined), stand oil, poppy oil and walnut oil. The oil medium offers ease of manipulation, flexibility and strength when dry.

Dry pigments are usually ground with a small amount of an oil medium to form a stiff paste. The viscosity or thickness can be altered by the addition of turpentine.

The rate of drying can be controlled by the use of stand oil or poppy oil for slow drying, or refined linseed oil for faster drying.

All these media, in combination with damar varnish, beeswax, Canada balsam or copal varnish, can be employed as a final picture varnish.

Mixed Media

Acrylic paints are very versatile, lending themselves to more mixed media applications than any other materials available to the painter.

Underpainting in acrylic can be followed by glazes and scumbles of oil paint, and various other techniques can be applied such as opaque technique, transparent technique, a combination of both, and tempera technique. The underpainting can be applied smoothly by means of fluid paint, or with a rough texture.

A word of warning: Oil paint on acrylic underpaint is permissible, but acrylic overpainting on an oil underpaint will result in failure.

Watercolor can be blended with acrylic medium and with inks and dyes by adding matt or gloss acrylic medium.

For inpainting of paintings executed in oils, copal painting medium will satisfy every possible demand. This usually comes in two varieties, light and heavy. The heavy medium can be used for general work requiring a heavy application of paint. The light medium should be used for glazing only.

The advantage of using copal-based medium is twofold: first, it adds binding power to the paint itself; and second, by improving the binding power of the medium, copal resin helps it attach quickly to the surface, thus holding the thin paint in place.

Varnish

Varnish is a preparation made for the final coating of art objects. For oil painting the most often used, and the most durable, is formed from damar crystals dissolved in turpentine. This should be stored in sunlight, which causes a bleaching action and so maintains the light tone of the varnish.

As a final coating, mastic tears dissolved in turpentine over heat, or copal crystals dissolved in benzine and turpentine, also produce hard and highly resistant mixtures.

Very quick drying varnishes are based on damar varnish plus stand oil, and dissolved in toluene.

To obtain a very high gloss on the final varnish, damar varnish should be mixed with mastic varnish and wax and dissolved over a hot plate.

For all gum-, glue- and casein-based paintings, a mixture of damar varnish, stand oil, toluene and alcohol works well.

For watercolors and other water-based paints, a glue varnish is suitable. This varnish consists of leaf gelatin, hide glue and distilled water solution.

To isolate layers of gum, glue and oil paint, an isolate varnish is used, consisting of shellac crystals and powdered borax, mixed in boiling water. It can be diluted with distilled water or methyl alcohol.

Tempera paintings can be sprayed with a diluted damar varnish. After three to four weeks of drying, beeswax diluted with turpentine over heat can be applied hot with a spray gun, left to dry for a week and then rubbed with hard pressed felt.

Retouch varnish is a diluted damar varnish. It is used to restore the optical effect during painting or restoration work. It also provides temporary protection and improves the painting's visibility immediately after the painting is skin-dry, or before it is fully varnished.

Many old paintings show uneven gloss on their surface which looks patchy and dull in places. To remedy this condition, equal parts of copaiba balsam and turpentine are brushed very thinly over the painting. This mixture can also be combined with retouch varnish or applied on its own, before application of the final varnish.

Lacquer

Lacquer is a resinous varnish obtained from a Japanese tree, used to produce a highly polished, lustrous surface coating. These days, it is usually made from resin, cellulose ester or both, dissolved in a volatile solvent, sometimes with pigment added.

Driers and Siccatives

The use of driers and siccatives in painting, repair and restoration work should be avoided, especially when using cobalt linoleate. It is highly inadvisable to use these substances in the top layers of paint, glaze or varnish.

Most of the naturally based paints and paint media on the market today include fast-drying oils and resins, which improve the drying rate.

Fixatives

Fixatives are used mostly on pastel, charcoal and chalk paintings, where the preservation of the powdery surface is the main purpose. The coating supplied must be light enough in solution to be sprayed on, and clear enough not to appreciably discolor the work being fixed.

The main ingredients of good fixatives are *bleached shellac* dissolved in alcohol; *skim milk* — one of the oldest methods of fixing drawings; *egg yolk and water mixture*, well shaken; *mastic varnish* diluted in ethyl acetate; *damar varnish* diluted in benzene; and *Venice turpentine* diluted in alcohol.

Ink

There are literally thousands of formulas for producing ink.

Writing inks can be found in three main groups: *iron gall ink*, a highly acid black, brown or purple pigment made by combining oak galls with ferrous tannate; *vegetable ink*, based on vegetable dye pigments, such as those obtained from pomegranate peel; and *carbon ink*, usually made from lampblack mixed with a weak solution of potassium and diffused through slightly alkalized water.

Most of these writing inks are water-based with gum arabic added, as well as pure sulphuric acid.

Printing inks have a deep black color obtained from very fine carbon derived from pine wood. The finest inks are made from flame lampblack. These inks are very fast drying and based on linseed oil, rosin and soap media.

Ink for stamps was made by rubbing up pigments in fat to form a paste. Now most stamping inks are made without grease and contain nothing but glycerine and coaltar dye.

India, China and Japan inks are based on lampblack, alkalized water and gelatin.

Marking or labelling inks consist of borax, shellac, lampblack and water, all mixed under heat.

Indelible inks, often called *indestructible inks,* are made from aniline oil, potassium chlorate, hydrochloric acid and distilled water.

Painting Textures

Several techniques are available to provide desired textures.

Splattering—tapping a brush loaded with paint over the painting, starting with lighter tones and then darker tones. The painting can be held in a vertical or horizontal position.

Stippling—with a brush, employing short up-and-down motions, keeping the brush perpendicular to the panel. The more the stipple, the smoother the surface will become.

Sponging—by the use of a sponge dipped in wet paint. If possible, a lighter color should be used over a darker underpaint.

Blotting—with cheesecloth or a toothbrush, in quick, little dabs.

Scraping—using a knife or razorblade and scratching out the paint.

Tapping—using a brush for tapping and then pulling the brush away, thus depositing infinitesimal points of paint. The brush can be held vertical or horizontal to the painting.

4. Repair and Renovation

The important role of the restorer in the connoisseurship and conservation of art has been expanding dramatically since the early 1950s. Demands for conservation and restoration, especially restoration of paintings, have grown almost exponentially. At the same time there is a dearth of practicing restorers — only a handful of professionals available to cope with a flood of precious and priceless paintings.

There are some misconceptions about the work of the restorer. Actually, no one can restore a painting. The best that can be achieved is to *conserve* — arrest the elements which contribute to injury, decay and waste; *preserve* — protect what is left from harm or injury, especially from the decomposition of varnish, paint, canvas or paper; and *renovate* — return the painting to a former and unimpaired condition.

Examination

Examination of paintings is an extremely interesting and fascinating field of endeavor. It is very broad in its scope and hence offers many specific lines of interest and specialization.

There are many fundamentals of theory and analysis and a great deal of factual information with which every practicing restorer must become familiar. The material presented here is most basic to the practice of examination. By understanding the

materials that were used in the execution of a painting, how they were employed and their present condition, the restorer can decide upon a method of restoration. Technical investigation could also lead to the development of better and more reliable methods of conservation, as well as the ascertainment of the artist, school of painting, and period.

In order to establish the method, schedule and cost of restoration, the restorer should examine every painting in detail. Examination can be conducted visually or by photographic or instrumental analysis. Visual examination can reveal details and condition of frame, stretcher, support, ground and paint. Such examination discovers the physical state of the painting such as deterioration, wear and tear, holes and other damage.

Photo recording and examination, black and white or color, using normal or raking ultraviolet or infrared light, shows the true state of the object being examined. Raking light and ultraviolet light can establish deterioration of varnish or paint and show areas of overpaint, repair or alterations. Infrared light, which penetrates deeper, can display details hidden by dark varnish, such as shadows, a faded signature or even another painting hidden beneath the top layer of paint.

Photographs contribute greatly to the knowledge of a particular painting, and those taken before and after restoration work present a permanent record of the condition of that painting.

A pocket lens is an invaluable aid for general examination, and when it is combined with a binocular magnifier it offers freedom of manipulation with hands, and ease of focusing.

Certain tools are used occasionally for observing or recording evidence that is not apparent to the naked eye or with the aid of an ordinary magnifying glass. Numerous instruments are available for the scientific examination of paintings. For example, the microscope allows detailed investigation of pigment particles, their depression, the artist's brush strokes and deteriorating areas. X-ray examination allows complete depth penetration right through the full thickness of the layers of the painting, and a complete examination of the varnish layer, paint, ground and support.

A number of museums practice chemical and microchemical analysis to determine data on paints, varnishes and ground. The microanalysis of pigments can establish the correct age of a paint-

ing, as well as chemical reactions which have taken place and color variations before and after varnish removal.

Other scientific examinations can be conducted with the help of laser radiation, neutron activation, autoradiography and chromatography.

Damage Assessment

There are five main causes of damage to art objects.

Humidity. Excessive wetness results in the weakening of adhesives, rotting of size, staining of paper or vellum, blurring of inks, mildewing and fungi growth, metallic corrosion, slackening of canvas, activation of soluble salts, and bloom or clouding of varnish; also movement resulting in the warping of wood and the flaking of paint.

Excessive dryness. Lack of moisture will affect varnish and support, embrittling the former by dessication or tightening of canvas, and aging the latter; the support may warp, buckle and split.

Contaminated air. A concentration of sulphur dioxide in the air, produced by the burning of coal and other fuels, can be absorbed by paintings. It will decompose coatings, canvas, paper and other supports. Sulphur dioxide also leads to bleaching (and hydrogen sulfide, another pollutant, to darkening) of lead pigments and tarnishing of metals. Soot dust produces staining.

Air conditioning introduces a lot of fine dust which, in spite of filters, penetrates each area serviced. Dust is a major carrier of microorganisms and the very sharp-edged crystals of the dust-sand cut and scour the coating. If embedded in the coating, these can be removed only be a complete removal of the surface coating.

Pests. Moths, wood beetles, silverfish, rats and mice can all inflict damage.

Neglect — not only accidents, but also in the form of exposure to excessive light, heat, or contaminating objects — can cause damage. Exposure to light produces deteriorating effects when paintings are exhibited in the home or gallery. The radiant energy of visible light causes decomposition of the molecular structure of

varnish, paint, ground and support. Depending upon the composition of the surface, and the circumstances, the degenerating process may result in yellowing of varnish, bleaching, fading, or darkening. Diffused daylight, fluorescent and incandescent light would diminish this hazard considerably. As for contaminants, pulp mats containing resin or other chemicals can cause discoloration of paper; stretchers of unseasoned wood promote discoloration or instability of paint and frames; and alkyd-painted wall surfaces can cause damage to photographs.

Frames

Although very few restorers will undertake the repair or restoration of frames, it is essential that they be aware of the damage to which frames can be exposed, how to spot the damage and how to estimate for the required improvements.

As most frames are made of wood or wooden mouldings, we can look for loss of ornamental work; splits and openings in the wood frame, corner joints and moulding; and loss of paint, gold leaf and plaster moulding.

The frame restorer should have qualifications similar to the restorer of paintings. Only a skilled craftsman can replace mouldings, paint, gild and decorate a frame. The disciplined skills and time required account for the high costs of frame restoration.

Stretcher

The stretcher is the basic structural part of any painting; any damage to it will be transmitted to the canvas and may affect its tension, so affecting the ground and surface.

In the stretcher, look for the problem that may get worse or may be a disturbance to the support or frame. A crack or split in the stretcher is a sign that something has gone wrong and has to be rectified. Stretchers get warped, broken, split; the slotted corners open; tightening pegs may be missing, allowing the canvas to sag; woodworms may infest some areas.

Stretchers should be disassembled, pegs removed, slots cleaned and the stretcher fumigated.

Support: Canvas

After removal of a painting from the frame, the edges of the canvas bent over the stretcher should be inspected for damage such as splitting, cracking and distortion. Any noticeable damage means that the canvas cannot sustain the tension, which results in sagging of the painting and cracking of the ground, paint and varnish.

Some canvas supports may have been reinforced with another canvas, thick paper, cardboard, wood panels or metal sheets, and often these additional supports have separated in places, forming bubbles and even breaks in the original canvas.

Additional supports are usually attached with adhesives or wax, but most adhesives dry out quickly and lose their effectiveness. Canvases or paper put down on any support with wax medium are relatively easy to remove from their support, separating immediately when heat is applied.

If, however, the original was affixed to an additional canvas with natural glue, separating the two may turn into a lengthy undertaking. If the support was made of thick cardboard, plywood, masonite or wood panel, the canvas can be removed only by chiseling off layer after layer of the support material.

Most problems associated with additional supports occur when a wooden support splits open, develops cracks or is eaten by wood worm, all of which can result in the canvas splitting or the formation of holes. Cardboard supports are very fragile, easily damaged and bent at the corners, again resulting in damage to the canvas.

The canvas itself should be examined for wear and tear. Looking through the back of the painting against a strong light will show holes, cracks and damage to the individual strands of the weave. Both front and back of the canvas may evidence a variety of abuses, such as scratches on the front or pencil marks at the back, or labels stuck to the back of the canvas with glue causing contraction of the surroundng fabric.

The bottom part of the painting, especially the space between the stretcher and canvas, accumulates a lot of dust, fluff and floating dirt. This space was also used as a hiding place in the past for love letters, keys, rings and money.

Support: Wood Panels

Most frequently the panels for paintings are made from hard-wood: oak, mahogany, nut, olive. These woods have an extremely hygroscopic nature; they expand in a humid atmosphere and con-tract in a dry one. As one side of the panel is sealed from the air by ground, paint and varnish, only one side is exposed and affected by humidity. This discrepancy results in the panel bowing, splitting and breaking up.

Dry rot, which is a kind of fungus, does affect wood panels badly, working itself amongst the fibers. This action results in cleavage where wood has been weakened directly below the ground.

The worst damage to wooden panels is inflicted by larvae of beetles, which tunnel along the fibers, damaging the basic structure.

Warping of panels can be prevented by the construction of a special cradle.

Support: Paper

Due to their fragile construction, supports which have a paper base become distorted more than any other types; they get creased, folded, bent and torn. This kind of damage can be considered mechanical.

Other damage is caused by uneven shrinkage or expansion due to inappropriate mounting, introducing uneven tensions over the support area. The resulting grooves, wrinkles and bulges are difficult to eliminate. Application of the wrong adhesives to paper supports, likewise causes considerable damage. Formation of air pockets is usually the first sign of trouble, followed by splitting and tearing.

Mould growth usually manifests itself as *foxing*; small, scat-tered, brown spots on the paper. Foxing is the result of the mould drawing food from the cellulose in the paper, which causes a change in chemistry, turning it brown. Foxing is especially likely when glue size or adhesive has been used. High humidity is the main cause of mould growth.

Other damage to paper supports stems from dust, improper handling or exposure to light.

Water stains, with a characteristic dark brown fluid edge, show the hygroscopic behavior of paper. One small drop of water can spread itself over a fairly large area, and the water penetrating the paper carries with it dissolved impurities from paper and cardboard.

The original tone of any paper, when exposed to light, changes rapidly and the paper will become discolored unless protected by non-reflecting glass.

Surface Deterioration

The rate of surface deterioration depends upon the environment surrounding a painting and the composition of the surface coating material.

When varnish is applied to the painting, it appears at first as a transparent film, resembling thin glass. However, in time the clarity of varnish diminishes and the film assumes a yellowish-brown look. Sometimes faint bluish streaks are in evidence. This blemishing and discoloration is due to many factors. Some paintings are affected by impurities floating in the air, such as dust and grime. These particles have a tendency to absorb moisture, dissolving and sticking hard to the surface; such formation is very difficult to remove. The use of a dry method results in scratches, flaking paint or holes in the surface, and the use of alcohol or acetone weakens the surface. Discoloration in other cases is due to the darkening of the ingredients used as a binding medium in varnish manufacture.

The most noticeable discoloration on paintings is due to the darkening of varnish from auto-oxidation, loss of volatile oils and molecular rearrangement. Unfortunately, nothing can be done about this discoloration.

Bloom or clouding is due to the chemical or mechanical breakup of the varnish film structure.

During the sixteenth and seventeenth centuries some varnishes were tinted with stain, which today is referred to as "Old Masters Glow."

Two distinct types of breaks may appear on or in the surface: a *crackle,* which is a fine net of breaks in the varnish or paint surface;

and a *crack* which breaks through all the layers of paint and ground. Disfiguring crackle and cracks appear at points of maximum stress and may run diagonally, vertically or horizontally.

Cracks in the varnish film result from the break-up of the film itself, during the drying period, which usually takes several months. The surface tension of a dry varnish film may not withstand movement of the paint layer directly underneath, or the paint layer's expansions and contractions with the canvas. The cracks in varnish cannot be eliminated; the varnish layer has to be removed completely. The method of softening the varnish film and working this old varnish into the cracks produces only very temporary results.

As varnish is applied as a very fine coating, its hardness is minimal and therefore it is easily scratched. These surface scratches reflect the light and are very disturbing to the viewer.

Surface deterioration may also affect the paint itself. The construction of a painting may involve direct paint application to the support, or paint application over previously laid ground, and the sealing of the paint with varnish. Paint left unprotected by varnish can be exposed to abuse and subjected to movement in the support. When paint is applied over ground and is varnished, it is sandwiched between two tough layers and well protected, and some of the strain inflicted by movement of the support or other harassment is taken by the ground or varnish layers.

Damage inflicted to paint can be of a chemical or mechanical nature. It may result in scratches, marks, insect speckles, small dents, breaks and tears, worm holes, burns from candles or fire, sparks from fireplaces, scorching or heavy smoking. Other forms of injury to the paint manifest themselves in the form of pigment discoloration, fading, darkening and bleaching.

Chalking, which is frequently found on oil paintings, usually occurs when pigments suspended in the painting medium float to the surface of the paint layer.

Pentimenti, which is the reappearance of a design that has been painted over, is usually due to a progressive change of the refractive index in the oil medium.

Cracks in the paint result from it becoming brittle with age. Different layers of paint have different drying rates; therefore there will be different strains in the paint itself, resulting in the formation of splits in the paint along the lines of its own weakness. Cracks in

paint are more pronounced on wood panels than on canvas or card-board, as a greater strain can build up in such supports.

Canvases impregnated with a sizing material have a tendency to swell in high humidity, resulting in loss of tension and sagging of the canvas. In a hot, dry environment the canvases become tight, introducing high tensions in the paint and varnish layers; having no expansion capability, these layers are then subject to surface crackling.

Repair

Materials

Many factors influence the permanence of a painting, and they apply to each part of the painting structure: varnish, paint, ground, support, stretcher and frame. A painting is a fairly complex structure of organic and inorganic substances, and unless the restorer selects the proper repair material, resembling in composition and character the material used in the painting, there may be problems.

The choice of the proper tools to accomplish the necessary work is of paramount importance, and the initial outlay can be regarded as an investment for life. A discussion of the basic tools and materials follows.

•*Size.* This is a glutinous preparation made from gelatin, animal hide adhesive, casein, starch, egg and copal oil. It is mainly used for filling the pores of paper, fabric, or wood. Size also imparts an extra strength to fragile papers and thin fabrics. The restorer should establish the chemical composition of the size before using it so that no surprising side effects interfere with the work.

Products available on the market are not suitable for art restoration, and it is much better to make one's own size. Recipes can be found in any book dealing with art materials.

•*Gelatin.* This is a transparent glutinous substance which is produced by boiling animal tissue in water; it forms the base for adhesives. It is usually obtainable in leaf form. When used with paper products, the most common recipe is two gelatin leaves plus

one gallon of water. The gelatin is first soaked in a pint of cold water for at least twenty-four hours, then boiled until completely dissolved and poured into the remaining water.

For wooden panels, six leaves should be soaked in a pint of cold water, and the water then heated until the gelatin is dissolved. This mixture must be applied to both sides of the panel.

•*Casein.* Casein is a whitish phosphorus-containing protein found in milk. It is usually mixed with water and ammonium carbonate. It is often used in paint preparation as a binder.

The most common composition consists of two parts of casein powder, sixteen parts of water and one part of ammonium carbonate. The casein powder and ammonium carbonate should be stirred until dissolved in a little warm water. This solution is left to rest for about three hours and then mixed with the rest of the water.

Application is by brush, working the mixture into plywood, board or wood panels, always on both sides.

•*Starch.* This white, solid carbohydrate exists in the form of minute granules in rice, corn, wheat, beans and potatoes. It is used to stiffen and offer a quick drying protection to fabric and paper.

The formula recommended is one part starch, dissolved in three parts of cold water to form a paste, and then two parts of boiling water added.

Application is by brush to both sides of the surface.

•*Copal Oil.* This is obtainable in the form of hard and lustrous resin, a product of various tropical trees. Its use is mainly in sealing porous materials such as ceramic, stone and plaster.

Two parts of copal lumps are added to three parts of raw linseed oil, one part of paraffin and five parts of turpentine. This mixture should be heated until all ingredients are dissolved, and applied with a brush while hot. Two or three coats are advisable.

•*Egg.* There is every reason to believe that the egg was used from very ancient times indeed. Rediscovered comparatively lately, it is much favored by a number of present day painters. Its use covers a variety of applications in the preparation of fixatives, temperas, oil paints (to made them set quickly and dry hard), grounds and gold leafing.

Whole egg or egg white finds numerous uses in the art field as it can be employed on glass, stone and metal.

For use as a quick-drying size on canvas, or for isolating pencil or charcoal from paint, the following formula is recommended: one part egg yolk, thirty parts of water. To prepare, pour egg yolk into the water at room temperature and shake well until a consistent solution is obtained. This formula can also be used for a good isolating varnish, or by adding more water, as a fixative.

Application can be with a soft brush, but the use of a spray gun is preferable.

•*Gesso.* Gypsum or plaster of Paris, combined with an adhesive, was used in the old days to provide a preliminary coating of the surface for paintings. There are two basic formulas:

> 1. One part of kaolin, one part of whiting, fifteen parts of size. This should be mixed cold.
> 2. One part of zinc white, three parts of whiting, one-half pint of warm water. While stirring this mixture, add a tablespoon of raw linseed oil, drop by drop.

Gesso can be used on canvas, paper and wood panels, applied with a brush. A minimum of eight coats should be applied very thinly.

•*Paste.* This usually refers to a mixture of flour and water with starch added. It is used as an adhesive for paper products.

One formula is thirty parts rice flour, ten parts size, two parts glycerine, four parts molasses, one part thymol in ethyl alcohol, all mixed cold in one pint of water. When thoroughly mixed this should be boiled for at least ten minutes.

A second formula providing a strong adhesive quality is one pound rabbit skin adhesive, one cup of rice flour, one-quarter pint linseed oil, one pound of molasses, one-quarter pint glycerine, one quart of water. First the rabbit skin adhesive should be soaked in water until completely dissolved, and the rice flour should be mixed with water to form a paste. These two mixtures should be warmed and then combined. While being stirred the rest of the ingredients should be added.

•*Adhesives.* Substantial strides in the technology of adhesives have been made in the last decade. Modern adhesives stick better and faster than did their counterparts some years ago. Today it is possible to repair items that we would once have considered

irreparable. There are many types of adhesive available for art conservation and restoration work, but most have a very limited application. No adhesive could come under the heading of General Purpose.

Commercially available adhesives appear under a host of brand names, usually backed by fervent advertising claims for their strength and versatility; the important fact not stated is their chemical composition. The chemical reaction between the material of the object and the adhesive plays a vital role in art restoration; therefore it is imperative to know the contents of the adhesives and their likely reactions with various materials.

Water-based adhesives (paste) are good for simple, rapid work, without making an irrevocable bond. Animal adhesives can be used when a permanent bond is required. However, any water-based adhesive will shrink or swell when there are changes in humidity; they become brittle in a dry environment and have a tendency to grow mould very rapidly when left in damp surroundings.

Wax-based adhesives are excellent when light adhesion is required, and they are moisture-proof.

Synthetic adhesives should be used only when a permanent, strong adhesion is required; they are generally very difficult to dissolve.

In general, adhesives can be classified in two basic groups: natural and synthetic.

The natural group consists of products obtainable from *vegetables* — potato starch, sugar, oils; *trees* — rosin, rubber (caoutchouc), chestnut powder, gum; *insects* — beeswax; *fish* — fish glue, isinglass; *animals* — tissue, hide, casein; and *minerals* — waterglass, lead white.

The synthetic group comprises chlorides, latex, styrene, vinyl and urea products.

It is highly recommended that natural adhesives be used in the conservation of art. Although they involve a lot of preparatory work such as crushing, mixing and boiling, the ingredients used have been proven in the past and their chemical composition is well known.

Hundreds of variations and compositions can be devised from natural sources, and one has to remember that each specific task requires a particular type of adhesive only; the adhesive prepared for

binding pieces of cardboard, for instance, will be useless for application to very thin, highly hygroscopic paper tissue.

We can now look at adhesives in greater detail.

Adhesives are based on products from:

vegetables Paste — wheat or rye flour mixed in cold water and diluted with boiling water
— potato starch mixed with sugar and water, or horse chestnut, pulverized and mixed with hot water
— cellulose, the chief constituent of plants, cotton, hemp, paper

trees — gum arabic, an exudation from acacia, mixed with water
— gum resin, a plant exudation consisting of a mixture of gum and resin
— gum arabic, starch and sugar boiled together
— natural rubber, indian rubber called *caoutchouc*, dispersed in a volatile solvent
— rosin, a turpentine distillant of pine tree, dissolved in gasoline, alcohol, paraffin or turpentine

insects — shellac, a resinous substance, droppings of the lac insect, dissolved in alcohol or similar solvent
— beeswax combined with rosin

fish — fish glue, a dried fish that has been ground, mixed with water and boiled with the addition of gelatin
— isinglass, extract obtainable from sturgeon's bladder, mixed with water and acetic acid or alcohol

animal — hide glue made from the pelt of large animals boiled in water
— gelatin, obtained by boiling animal tissue in water
— casein, an emulsion made from milk protein mixed with water and ammonium carbonate

mineral — waterglass, a pure sodium silicate
— lead white and linseed oil

synthetic (In the form of contact, paste or liquid)
— contact adhesives bond immediately, giving a heat and waterproof joint; once the bond is made the two parts cannot be separated. Usually soluble in acetone or carbon tetrachloride. Good for laminates, hardboard, metal and wood.
— Cyanoacrylates, so called "super-adhesives," bond instantly and will stick "anything to anything." There is no solvent available.
— Epoxy, a two-part adhesive consisting of a resin and a hardener, providing an emmensely strong bond. It can be used with any hard material.
— Latex, a product made from synthetic rubber, mainly used for sticking fabrics, is waterproof.
— PVA, polyvinyl acetate, a nontoxic thermoplastic resin, providing a strong, flexible bond. Moderately waterproof.
— PVC, polyvinyl chloride, used only for sticking flexible PVC materials, providing a strong, quick setting bond.
— Polystyrene, used only for rigid polystyrene products. It softens the plastic, which then welds together as it hardens again.
— Urea formaldehyde, usually in the form of powder which is mixed with water and applied. The bond sets when the two surfaces are brought together.

•*Painting Media, Oil-based.* The durability of a painting depends upon the chemical reactions of the ingredients used to prepare a suitable painting medium, which combined with paint forms the paint layer. Chemical purity is very important to provide a long-lasting, flexible and easily manipulated painting mixture.

The complete drying process usually takes several months, but at the time of painting, this mixture can be treated to provide either a fast or slow drying process, which in terms of time can be looked at as a temporary drying. However, in order to maintain chemical purity, fast or slow drying agents of unknown ingredients should be rejected.

It is of vital importance to have a general knowledge of what

makes a suitable painting medium and how it works. The essential proportions of ingredients which are proven and dependable are:

1. One part sun-thickened linseed oil, one part Venice turpentine, one part turpentine. This is fairly slow drying and should be used sparingly. To prepare, heat all the above until a uniform mixture is obtained.

2. One part heavy stand oil, one part damar varnish, five parts turpentine. This dries more rapidly than linseed oil–based medium, usually three days. Viscosity can be changed by adding more turpentine. To prepare, stir and shake above ingredients together at room temperature.

3. One part sun-thickened linseed oil, two parts mastic varnish or damar varnish. Drying time is about two days. This medium provides a clear and tough mixture, smooth and easy to apply. To prepare, combine the above ingredients together at room temperature and let stand for a day.

•*Paints.* The use of *oil paint* for retouching is discouraged; any oil-based paint will darken in time, losing its matching quality.

Watercolor. For retouching, this should be of the best quality, preferably in tube form, and mixed with distilled water with a few drops of wetting agent added. The color should be tried on a piece of plain white paper to check the tone after the paint is dry.

Egg Tempera. Powdered pigments or watercolor in tubes should be mixed with emulsion prepared from the yolk of an egg and distilled water. Usually a few layers are applied, starting with a light tone and gradually building up with darker tones until the desired color match is obtained.

Qualities to recommend this medium are its fast drying ability, durability and permanence due to the fact that it is a natural emulsion resulting from egg and oil particles suspended in water. This emulsion produces a tough, insoluble medium with rapid temporary drying. The complete drying process, however, requires at least fifteen months.

Several formulas can be recommended, depending on the technique of painting being used.

For *cross-hatching technique:* one part egg yolk, one part water, a few drops alcohol.

For *underpainting:* one part egg yolk, one part damar varnish, one part water. Add damar varnish drop by drop and stir.

For *a very tough and insoluble finish:* four parts whole egg, one part damar varnish, twelve parts water, and a few drops of oil of cloves.

To prepare this medium, crack the egg and separate and discard the white. Slash the sack and squeeze the yolk into a container. Add water and stir until a light, creamy mixture is obtained, and store this in the refrigerator.

•*Varnish.* A selection of good quality and proven products should be on hand, such as retouch, damar, copal and matt varnish. It is highly recommended that varnish be applied with a spray gun, in several very thin coats. The varnish should be warmed to human body temperature, except in the case of matt varnish, which should be applied hot. In all cases the spray gun should also be warmed.

•*Glazes.* For oil paintings:

1. One part damar lumps, one part turpentine; stand in a bottle in warm sunshine and agitate daily over a one-month period. This glaze is heavy and tough and dries rapidly.

2. Four parts heavy stand oil, one part beeswax, eight parts turpentine; combine and heat, shake well and let stand for at least three days.

3. One part sun-thickened linseed oil, one part Venice turpentine; combine at room temperature and apply in very thin coats. This dries within three days.

•*Emulsions.* For underpainting: Casein emulsion — one ounce pure casein well stirred into seven ounces distilled water; let stand for at least five hours, then add one teaspoonful of 5 percent ammonia solution or two small cubes of ammonium carbonate dissolved in a teaspoonful of water. Stir well and heat.

For painting: to one whole egg add damar varnish or stand oil to about one-third of the bulk of the egg; stir well and add water, then strain through cheesecloth to eliminate unbroken particles of egg.

•*Fixative.* For chalk, charcoal, pastel:

1. One part mastic, twenty-five parts ethyl acetate; stir well at room temperature. Blow through an atomizer or spray, holding the painting flat on the table. Prevent any accumulation of fixative on the surface.

2. One part shellac lumps, fifty parts methyl alcohol; stir well at room temperature.

For gouache paintings: Four leaves gelatin, one-half pint of water, one-half pint of alcohol; combine the warm water and gelatin until dissolved, then add alcohol.

•*Siccative.* To accelerate the rate of drying of glazes and paint media: eight parts raw linseed oil, one part white lead dry pigment; simmer oil over heat, adding small amounts of pigment until dissolved.

•*Plasticizer and Stabilizer.* For oil paints: four parts cold-pressed linseed oil, one part poppy oil; stir well and let stand for two days.

For worm-eaten wood, rotted canvas and weathered objects, to seal out air and moisture: one part beeswax, one part turpentine, heated over a stove.

•*Wax.* Adhesive for canvas repair and infusing: one pound beeswax, one-quarter pound gum elemi; melt in a double boiler, pour on a tray and, when cool, cut into one-inch strips.

Wax paste and filler: one pound beeswax, one-half pound damar resin, one-half pound paraffin, one-quarter pound gum elemi. Melt in a double boiler for two hours; then add sufficient kaolin to thicken the mixture.

•*Brushes.* Oil painting brushes are made of hog bristle, sable or badger hair. There are six basic shapes required for inpainting and each of them produces its own stroke and texture. They are *round*; *flat*; *filbert*—a cross between round and flat; *sword*—with a 45°edge; *rigger*—small, round and very soft with long hair; and *sweetener*—fan-shaped, flat and broad.

The cost of brushes is fairly high, so they should be treated very carefully to prolong their life. During painting, and when not in use, they can be kept in a shallow basin filled with water. It is important to keep them at a very shallow angle with only the hair submerged to prevent bending of the bristles. Clean them in a similar fashion, submerging them in a good brush cleaning liquid. Soap, turpentine and mineral spirits are not suitable.

•*Materials for Canvas Repair.* These include:

1. Fine linen or silk of very fine quality for patches.

2. Good linen to be used as secondary support.

3. Linen for patching holes of a thickness and weave pattern consistent with the original support.

4. Adhesive.

5. Strips of linen canvas to support the original canvas along the stretcher's edge: three inches wide with chamfered edges.

6. Thin plastic sheets, thin tracing paper.

7. Tools: knives, scissors, razor blades, spatula, hot iron, vacuum pump.

•*Paper.* Rag paper of various qualities, thickness and size will be required for some specific applications, and pulp paper for general use. Much paper is used during normal work in the studio; there never seems to be enough of it available. Blotting paper, tissue paper, paper handkerchiefs, even a roll of paper towels will always find some use. However, pulp paper should not be used in the actual execution of repairs as this paper is made from wood fibers, usually ground and separated by the addition of sulphuric acid and arsenic, and it may discolor and introduce the growth of mould.

For any repair to a paper support, use a paper with a lower shrinkage tendency than the paper support; that is, the repair paper should not exceed the support in thickness or strength.

A selection of good mulberry paper of various thicknesses, tones and textures should be on hand. (A hinge of tough-fibered mulberry paper is required for affixing a painting on paper to the backboard or mat.) A good chamfering tool is a necessity for repairing holes.

To secure a permanent mechanical bond during the repair of tears in paper, use a paper pulp. This pulp can be made by fuzzing an unsized paper of the same characteristic as the support and mixing it in a very weak solution of starch and rice flour, forming a paste. After being left for about three hours to settle, this solution is then laid across the tear on the reverse of the painting, and the pulp fibers are teased out so that they link with the edges of the tear or hole. Thus the thickness of the paper is only slightly increased and there is no line at the edge of the mend.

Cellulose powder is used for small holes such as worm holes, or gaping holes and small cracks. It is prepared by mixing the powder with sodium carboxymethyl cellulose and warm distilled water.

Commercially available paper or plastic tapes, or gummed tape such as masking tape, Scotch or Cellotape, are not recommended in any kind of restoration work — paper, canvas or wood. First of all, they are not durable and become loose in time as they dry out. Second, they are very harmful, especially to paper, as the adhesive of the tape penetrates into the paper, hardens and leaves ugly stains which are extremely difficult to remove.

Any work involving paper repair requires two plate glass surfaces, good quality blotting papers and wax paper.

•*Cardboard.* Hard and soft cardboard, light and heavy — all will find plenty of use in restoration work as working surfaces, supports and packing.

•*Wood.* Plywood, solid panels, soft and hard woods are very useful materials for the restorer. The demands for wood are many, as supporting surfaces, inserts for frames and stretchers.

•*Nails and Screws.* A wide selection of nails and screws should be on hand. Whenever possible, brass, copper or aluminum products should be used, to avoid rust.

During repair and mending of fragile pieces of wood, the use of a pilot drill is an absolute necessity; this will prevent the wood splitting and provide a proper guidance of the nail or screw. In the case of screws, a clearance drill is required to prevent straining of the screw, and in the use of a counter-sunk head screw, a proper opening to accommodate the head should be provided.

•*Materials for Metal Repair.* With very rare exceptions, paintings on metal support are made on a flat, smooth surface. They have a weak bond with paint and ground, and if subjected to sharp blows, the metal support vibrates, which results in paint surface breakage and cleavage.

Keep plastic putty on hand as a filler for deep scratches and small holes.

You will also require a press and adhesive for dents and bulges. Once the metal plate has been subjected to strain, the only means of repair is to affix it to a solid, preferably three-quarter inch, plyboard, with a good bond adhesive; it is then flattened under a press.

Frames

The main structure of the frame is fabricated from wood. The ornamentation of the frame may be carved in wood and moulded from plaster. The finish may consist of gold leaf, paint, oil or water stain.

The construction of the frame can be one solid piece of wood, four sections joined together at the corners, or several sections which fit inside each other and are held together by means of adhesive and nails.

Most visual damage to a frame is due to dust and dirt which enters grooves, slots and carvings on the front, or to the opening of the mitred corners. The latter involves laborious repair work as the hardened adhesive and holding nails have to be removed, and the joints cleaned of the existing rough spots. Framing clamps with a special attachment for a saw guide have to be used to provide cleanly mitred corners. During reassembly, strong adhesive and nails or screws should be inserted, using the appropriate body drill to prevent the wood splitting, while the frame corner is held tightly in the corner clamp. A thin, triangular plywood board can be affixed, with adhesive and wood screws, to the back of the frame, covering the joint. This will provide additional strength and support.

Do not hammer or bang on the frame; to do so could cause cracking of the frame mouldings.

Any imperfections to the front of a frame should be treated with gesso applied hot, with a brush, in a liberal coat; while this is still moist the appropriate frame pattern can be simulated.

Repairs to frames may involve patching of holes and cracks, moulding of part or complete ornamental assemblies, and repair of damaged corners.

Antique finish plays a very important part in frame restoration as the frame must compliment the period and character of the painting. The front of the frame can be cleaned with a soft brush and polished with an antistatic cloth. The surface finishing may include gold leaf repair, touching up with matching paint, staining or varnishing.

Looking at the back of a frame one sees the picture-hanging wire looped through a pair of eye screws. This assembly requires particular attention because, quite often, both screws become loose

and the wire gets worn out. As a rule, both screws and the wire should be replaced during the restoration work, irrespective of their condition. The corrosion concentrated inside the wire is seldom noticeable, and by replacing the wire at low cost one may prevent costly repairs further on, by preventing a fall from a broken wire.

The back of the frame should be cleaned of all accumulated dust and dirt, with a stiff wire brush. The picture recess must be clean and free from any foreign matter, so that the picture sits flat inside the frame.

It is recommended that every picture frame brought into the restorer's studio be fumigated to eliminate living organisms such as silverfish and wood worm.

When the painting is secured in a frame, the back of the assembly should be protected by means of thick laminated cardboard, fitted over and attached to the stretcher or frame structure. There must be openings in the board at the top and at the bottom to allow for air circulation. This protective board helps to keep the dirt away from the back of the painting and also offers a shield against damage to the canvas support. Quite a number of very valuable paintings have suffered considerable damage for want of an inexpensive corrugated cardboard shield.

Paintings should be fastened to the inside of the frame only by means of suitable clip fasteners attached to the frame by wood screws. Hammering of nails through the stretcher is not recommended.

Hanging a painting involves a bit of ingenuity. The hanging wire should be affixed approximately one-third of the way down from the top of the frame; this provides a slight inclination of the painting from the wall, which prevents dust and dirt from settling on the surface of the picture and offers a better optical effect for viewing.

Stretchers

After removal of the support and disassembly of the stretcher, each part of the latter should be cleaned of dirt, resanded and fumigated. Most of the dirt and grime imbeds itself in the wood

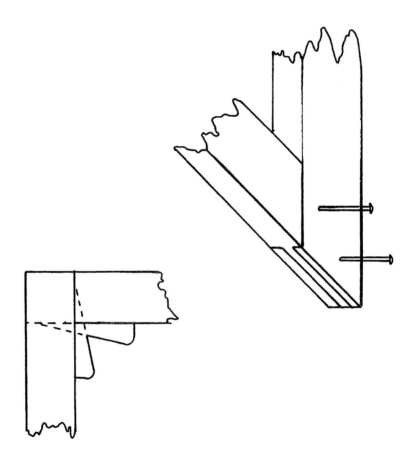

fibers, penetrating deep inside the wood; this applies to key slots, corners of the stretcher, etc.

When reassembling the stretcher, the rectangular form, a 90° angle at each corner, should be preserved. This is relatively easy to achieve by lightly nailing all four corners and removing these nails before the wooden wedges or keys are tapped in (Fig. 3).

Before inserting the assembled stretcher into the frame, and before the support is attached to the stretcher, a gap of at least one-eighth inch should be maintained all around the stretcher, to allow for taking up slack when stretching the support.

When restoring old paintings one has to remember that old canvases have taken a lot of strain around sharp 90° edges resulting in damage to the canvas weave.

It is advisable to round off the edges of the stretcher to increase the contact area, thus reducing the pressure on the canvas. To separate the support from the flat areas of the stretcher, thick cardboard or wood strips can be affixed along the stretcher; this will diminish or decrease the formation of ridges on the painting as the canvas support will be raised off the stretcher (Fig. 4).

Remember that the stretcher forms the main foundation of a painting, and all parts of it must therefore be in perfect order and condition. Many valuable paintings have been damaged by broken slat ends pushing and splitting the canvas, or by split wood along the edges cutting the canvas.

•*Modification of a Fixed Stretcher.* Some paintings may have been secured on a stretcher of a fixed type. It is hardly possible to call that type of structure a stretcher; it would be more properly described as a framework.

If possible, this framework should be replaced by a conventional, expandable stretcher. However, if the originality of the painting has to be preserved, the original framework can easily be modified and converted to an adjustable type (see Fig. 5).

In the case of a framework made of four pieces of wood, with corners cut at 45°, glued and held by nails, each corner has to be cut along the joint. Before this cut is made, four pieces of steel plate one-sixteenth inch thick, in the form of a triangle, should be prepared. Each corner of the framework is then slotted in the

Fig. 3. Reassembly of stretcher.

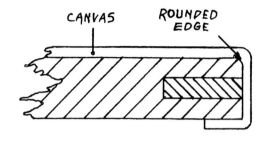

CANVAS

ROUNDED EDGE

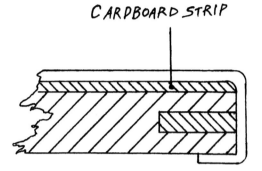

CARDBOARD STRIP

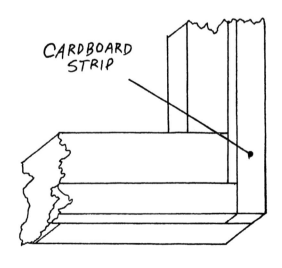

CARDBOARD STRIP

middle of the wood thickness, so that the steel plate can be inserted. The steel plates must fit tightly in these slots. When satisfied that all plates fit perfectly, remove all four; only then can the cut across each joint be made. All four pieces of framework are then reassembled, the steel plates inserted, and the painting, or secondary support, attached. To tighten the canvas, hardwood wedges are hammered into each of the corners, above the level of the plates. To prevent the wedges slipping out from the joints, a drop of adhesive can be placed over them.

Support: Canvas

Mending the support involves the ability to preserve the continuity and strength of the material of which it is made, and to prevent and minimize further damage; to make the damaged part whole, sound and available for ground application and paint by repairing and correcting visible defects.

The primary requirements of restoration of canvas are an understanding of the problem, and the appropriate choice of material, tools, and methods to carry out the work.

Damage to canvas can manifest itself in several forms. Each one has to be examined separately, analyzed and appropriately rectified.

It has to be stressed again that canvas is the principal support, a foundation of the painting, and without proper care the work involved with other repairs such as ground reconstruction, surface repair, inpainting and varnishing, may become a total disaster.

The most common damage sustained can be summarized under the following headings.

•*Grooves.* The back of the canvas is often damaged by pencil, pen or chalk writing, ink stamps or water-based adhesives. All of these exert a pressure that weakens the weave and quite often penetrates through the ground, paint and varnish of the surface. This penetration results in the formation of grooves, leading to fracture of the surface and loss of paint.

Repair involves application of wax resin around the damaged

Fig. 4. Location of cardboard strip.

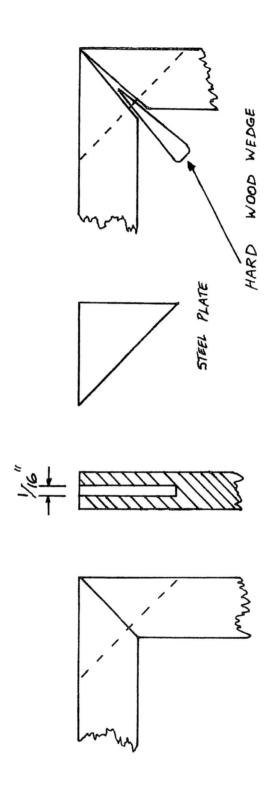

1/16"

STEEL PLATE

HARD WOOD WEDGE

area, hot pressing and application of weights, or a vacuum technique.

•*Wrinkles.* The formation of wrinkles on a painting may be due to excessive use of adhesive in the preparation of the ground, or too much linseed oil application when painting, or insufficient time allowed for drying between paint layers; the result is the formation of unstable areas on the painting. These areas can be softened with turpentine, alcohol or acetone, warmed by radiated heat (holding the hot iron above the wrinkled area and pressing gently through a waxed paper), and then held down with a weight. This is a very delicate operation because any pressure applied to force the paint back may dislodge and lift off the softened area.

•*Bulges.* Some paintings, if hanging loose on the stretcher, form bulges and folds in the canvas; these are difficult to eliminate. The canvas is usually dry, and the bulge inflicts a lot of strain on the surface of the painting. Before any pressure is applied to eliminate the bulge, the back of the canvas has to be softened. Turpentine or mineral spirit should be applied in several sprayings and the painting covered with a heavy rubber blanket, sealing this blanket along the edges; this will allow the spray mixture to penetrate the canvas, and the weight of the blanket will force the bulge out.

The canvas should be removed from the stretcher and placed on a glass or plastic panel before the application of the blanket.

•*Dents.* Most dents are due to excessive pressure exerted on a very small area of the canvas. It usually happens when bits of stretcher keys, nails or hard dust are lodged in the space between the canvas and stretcher. Also, resting the painting against a sharp edge of a chair or table will push the canvas out, often cracking or breaking the painted surface.

The only remedy for such damage is a complete attachment of a secondary canvas support.

•*Ripples.* These are usually small breaks in the smoothness or evenness of the painted surface, forming undulations and ruffles. Ripples are caused by aging and running paint or varnish which has not set or dried properly due to excessive application, or uneven canvas due to knots.

Fig. 5. Modification of a fixed stretcher.

Removal involves scraping off and smoothing the uneven-
ness.

• *Tears.* Lacerations of the canvas are due to a force which pulls
the support apart, leaving ragged and irregular edges. This happens
when a painting is pushed or snagged violently against a sharp ob-
ject such as a nail, producing shredding and separation of the canvas
fibers.

Temporary, preventive reformation of the canvas should be at-
tempted as soon as possible because the torn fabric will otherwise
start to curl and fold over, damaging the remaining paint over the
tear area. All frayed and loose fibers should be separated from each
other, rejoined evenly, flattened, and then have adhesive tape
pressed over them. No water or water-based adhesive should be
used.

The mending of the tear should then be performed in the
following stages:

 1. Clean all dirt and any foreign objects from the back of the
canvas.
 2. Pull the threads around the tear together.
 3. Carefully align and, if necessary, trim the frayed edges
and loose fibers to preserve the canvas pattern.
 4. Cut very thin patch material, such as muslin, cotton, silk,
or strong rag paper, to size, overlapping the dimensions of the
tear. Fray or chamfer the edges of the patch and place it over the
tear. Apply hot wax resin and flatten the area with a spatula
while cooling.

The torn area over the front of the painting should be pro-
tected during this operation by facing it with paper and appropriate
adhesive.

Small tears can be repaired with the help of very thin patches
using the above method.

One must remember, however, that patching of canvas is never
satisfactory. The flat surface of the painting is usually disturbed by
the material thickness of the patch, which is usually visible. The
only safe method is to provide a new backing canvas, a secondary
support.

Patches found on old canvases may be difficult to remove as
they were often applied with thick canvas and hard water adhesive

or white lead and linseed oil. No water should be used on the canvas to soften these patches, but grinding with a rotary cutter, or scraping with a sharp knife or sandpaper, can be attempted.

• *Split.* This is a division, break or separation of canvas, usually lengthwise, without the action of external forces and mostly due to stress. The division is frequently a clean separation requiring mending when all surface tension is removed.

The repair of a split requires the same method as repairing a tear, except that strong silk strips are laid across the split, attached with wax resin and left under pressure for a period of time. Again, in the case of a very small split, the silk strips may hold the opening together; however, it is always better and safer to apply a new back canvas across the whole painting.

In the case of major damage, "invisible mending" of the canvas may be necessary, which requires a great deal of patience and highly exact work.

• *Holes.* Renovation of missing parts of the painting (holes) involves a thorough reconstruction of the area, which necessitates the choice of canvas the same or similar in structure as the original; this includes the weaving and the thickness of the threads. The ground and paint applied must also be of the same consistency as the original painting.

The edges of the hole are cleaned of loose paint and loose fibers and a piece of the new canvas is cut to fill and fit exactly into the missing part. To facilitate a clean and even cut, the new piece of canvas is impregnated with polyvinyl acetate adhesive, and when thoroughly dry, it is placed underneath the hole, marked with a pencil and shaped and cut to the contour of the hole.

A very thin muslin or cotton patch is then coated with polyvinyl acetate, placed over the hole at the back of the painting and fused to the tightly fitted canvas insert. The use of a weight is recommended to insure some pressure to hold the patch evenly while drying.

Another method is the use of wax resin for affixing the patch. This is quite satisfactory, the only problem being that the insert canvas has to be properly sealed with gesso to prevent seepage of wax resin over the face of it, which would necessitate laborious wax removal. The insert canvas has to be impregnated with the gesso before it is shaped to the form of the hole.

Very small holes can be filled with a gesso patch applied to the back of the canvas, and then part of the gesso removed to allow ground application.

The use of linseed oil–based fillers should be avoided as they shrink and crack, and in time the oil darkens the applied colors of the inpainting.

•*Flattening.* Loss of tension in the canvas produces much deterioration in the fabric, ground, paint and varnish. The resulting symptoms have been described in previous pages. However, when no visual damage has been inflicted and only repair of the fold or bulge is required, this repair can be accomplished by removing the canvas from the stretcher, placing it face down on a solid flat plate (glass if possible) protected by a sheet of paper, and spraying the back of the canvas lightly with turpentine or mineral spirit. An over-sized sheet of wax paper is then placed over the canvas and a light pressure applied by vacuum or weight. It may be necessary to repeat this process several times over several days, each time applying more and more pressure.

Application of heat to flatten the canvas is not recommended.

•*Worn Canvas.* The treatment of a weak and worn-out canvas, too fragile to maintain its own weight and tension on the stretcher, requires the attachment of another canvas at the back of the original. However, when the canvas is worn thin only in a small area, exposing the ground, it can be mended with thin muslin strips and wax resin. The patched area must remain flat, so that the edges of the muslin strips remain indistinguishable.

•*Edging Reconstruction.* Most old paintings show a lot of damage along the fold where the canvas is bent over the edge of the stretcher, and around the tacks which secure the canvas to the stretcher. Dry canvas becomes brittle, and when tension is applied during stretching it may split along the sharp edge of the wooden slats.

If disintegration of the canvas fold is along a small area, it does indicate a weakness of the material, and repair should cover all edges of the painting. This can be carried out by placing a suitable strip of thin linen along the fold, on the back of the canvas, overlapping the edge of the painting by at least one-half inch all along, and securing it to the original canvas with wax resin. Another strip can be placed on the front of the painting one-quarter inch over the

edge so that it will be invisible when covered by the inner part of the frame. This strip should also be fused to the strip affixed underneath, as mentioned previously.

The most satisfactory method of repair is the attachment of a secondary support to the painting. The damaged edges should be marked with the help of a straight bar and cut with sharp scissors or a razor blade, applying as little pressure as possible so that the surface of the painting is not cracked, chipped or otherwise disturbed.

•*Water Damage.* Some paintings suffer from water damage, which is usually inflicted during storage, spills or other accidents. The outcome of such damage can include deterioration, weakening or decomposition of the canvas; lifting of grounds; and flaking or blistering of paint or varnish.

Repair of the affected areas is difficult because in the majority of cases, the ground has to be pulled back and secured to the canvas. This can be done properly only with the help of the vacuum technique and hot wax resin, working from the back of the canvas.

In the case of deteriorated canvas, a mulberry paper patch should be placed over the damaged area and the painting then affixed to a secondary support. The flaking and blistered paint has to be reattached by means of hot wax and spatula before the secondary support is applied.

•*Moisture Accumulation.* The effect of humidity on a painting is seen in the formation of wrinkles and bulges when humidity is high, and a very taut appearance of the support when humidity is low. While working in the San Diego, California, area this writer received many frantic telephone calls from art collectors, complaining that their paintings were alive, bulging in the early mornings and looking like a drum in the evenings. Around the small towns east of San Diego the day temperature reaches 120°F with a humidity of 2 percent, and at night the thermometer drops to around 34° F with humidity at 70 percent. Canvas is a highly water-absorbent material, and in most cases the backs of these paintings were left in a natural state and behaved like a sponge.

Old canvases were usually primed with a mixture of rabbit-hide chalk adhesive, and one wonders how these grounds can stand up to climatic conditions in England or Holland, for instance, or the southern United States.

Pictures displayed in places where the humidity reaches at least 70 percent should have their canvases protected with a layer of wax resin. This is a very simple process which can be done effectively on a vacuum table. In the case of an old painting, this not only forms a water barrier, but because of penetration of wax through the canvas, it insures a very satisfactory bond between the ground layer and canvas support. Any weak spots existing in the painting will be rectified immediately by the use of this method.

•*Fungus.* Fungi encompass numerous thallophytes such as moulds, mildews, rusts and smuts. They subsist upon dead or living organic matter, producing a growth in the form of downy or furry coatings.

Any painting with a water-based ground containing chalk is potential food for mould, which may appear in the form of light and dark spores formed in tight groups all over the painting, especially along the cracks or any damaged surface where there is an opening to allow oxygen intake.

Removal of fungi requires a thorough cleaning of the front of the painting and the back of the canvas. One of the most effective liquids is carbon tetrachloride, which should be applied with cotton wool pads to both sides of the picture.

When all growth has been removed, the painting should be fumigated, preferably with paradichlorobenzene. A tent of plastic sheets can be constructed over the painting and sealed along the edges, and a container with a fumigant placed inside. The released vapor will spread all over the painting. After fumigation, the canvas must be sealed at the back with wax resin, and all cracks or damaged areas of the painting surface sealed with varnish, to make both surface and back of the painting airtight.

•*Insects.* Some paintings sustain considerable damage from beetles, silverfish, moths, ants and other insects. This may take the form of small holes, eaten canvas parts or damaged paint. Ants are particularly destructive, consuming large areas of canvas, especially cotton and silk, while silverfish attack paint and ground.

Fumigation is the only way to eliminate these insects, and all inflicted damage should be repaired as quickly as possible.

The main problem with old canvases is that they tend to become extremely brittle with age and require very delicate han-

ling. Any bending, lifting of the corners or folding should be avoided, to prevent cracking of the surface.

When it is necessary to remove the painting from the stretcher, the canvas should rest and be supported at all times on a solid panel, preferably plywood board. To facilitate safe handling, it is advisable to use two solid plywood panels so that the painting is sandwiched between them when turned over, thus permitting work to be done on the surface or on the back. Naturally, the painting must be separated from the board by a thick sheet of paper to avoid direct contact between the wood and the painted surface.

The stretcher's assembly points (corners) must be properly identified so that during canvas reassembly on the same stretcher, all bars are in the same order and position as they were originally. The location of nails holding the canvas to the stretcher must be properly identified also, so that during reassembly the canvas is placed in the same position relative to the nails. The nails must be inserted in the original nail holes and the edges of the canvas reinforced with additional tacks. This will enable the preservation of original stress over the whole area of the canvas.

Before any repair is undertaken, the canvas must be freed of dirt and dust by brushing and vacuum cleaning. Any imperfecton visible on the back of the painting, such as weaving knots or loose strands of thread, must be eliminated and the surface must remain clean and in good repair for the intended work.

•*Facing.* To prevent any damage during the restoration process, storage or transportation, a layer of paper or fabric can be applied to the front of the painting. The material used should be thin, but strong and flexible. Mulberry paper or rag paper with long fibers and a minimum of sizing, or Japanese tissue paper is an excellent product for such use. It must be a material which will not shrink while drying or when heat is applied.

Quite often an architects' linen is used; when heat, moisture or pressure are applied, however, the texture of the linen may get imprinted on the surface of the painting.

The adhesives used should be soluble in solvents which do not affect the surface coating of the painting, and do not leave any deposit when removed. A good rule is to use water-based paste over resinous paint or varnish surfaces and a resin adhesive over water-soluble paints.

Recommended adhesives:

1. *Paste,* the most commonly used for facing when moderate strength and good flexibility are required.
2. *Thermoplastic synthetic resin polyvinyl acetate,* when monaqueous facing is to be achieved.
3. *Waxes* — beeswax and wax resin mixtures, when more permanent adhesion is needed.

•*Infusing.* Infusing implies the introduction of a substance which fills and permeates chosen materials. In the painting restoration technique, infusing involves the application of a coating material into the voids of porous supports such as canvas or other materials, which may be wood, metal or plastic. The main purpose is to consolidate a layer or series of layers of paint, to prevent the damage of peeling or flaking, or damage at the edges of separation cavities, holes, grooves and scratches. It will also stabilize and seal paint layers against moisture and correct dullness and opacity of paint, and permit a strong bond between materials.

The infusing material must penetrate deep into the voids of a porous paint, ground and support; show good stability to prevent later disfigurement and damage; possess ease of application and removal from the surface; and provide a strong and elastic adhesion. Materials used are size, linseed oil, polyvinyl acetate, wax and wax resin mixtures.

•*Assembly on Stretcher.* With an old painting where the canvas has had to be removed and the stretcher taken apart for renovation and repair, the first operation will be reassembly of the stretcher. Once again let us stress that the stretcher must be in a perfect condition, all slats clean, free of nails and the corners fitting easily in the slots. The technique of stretcher assembly was given in a previous paragraph, so assuming that the stretcher is ready to take the canvas, the final assembly of the painting can begin.

In the first phase, the painting must all the time be held in a vertical position to prevent sagging of the canvas through its own weight. It must remain vertical until all edges are secured and appropriate tension applied. Actually, as a rule, a painting supported on a stretcher should never be left lying in a horizontal position.

The shortest side of the painting is first placed on the stretcher,

Fig. 6. Action of forces on canvas in stretcher assembly.

and tacks, which have been recovered during canvas removal, are tapped lightly into their original position along the canvas edging. A similar procedure should be employed with the opposite side of the painting. Now the other two sides on the painting can be tacked in place. Examine the painting at this point for folds and unevenness of canvas. If necessary, the canvas positioning can be readjusted. Only then should additional tacks, placed between the existing ones, be hammered in, and folds along the corners properly positioned and attached.

There always seems to be a problem with the attachment of canvas edging at the corners. Hammering of a nail into the middle of the stretcher's edge will not be satisfactory. A method of canvas folding to reduce wear and tear at the corners can be explained by first showing the action of forces when the wedges are driven in. "A" shows the force generated by each wedge and the resultant force (R) acting on the corner of the slats' assembly. By rounding the corner, the resultant force will be spread over a bigger area and minimize puncturing or tearing of canvas.

Fig. 7 "A" shows the location of the stretcher over the painting. At least one and one-half inches of canvas should be available for folding. The first fold at the corner should be made as shown in Fig. 7 "B" and two tacks driven in to hold the fold down. These tacks must be short ones to prevent their penetration through the slat. The second fold is over the length of the slat and secured with tacks as shown in Fig. 7 "C." The third and final fold is over the adjoining slat and held down over its length with tacks, as shown in Fig. 7 "D."

The canvas should be pulled down over the edges of the slats fairly tightly. No wetting of canvas should be attempted to ease this operation as a wet canvas is a weak canvas.

•*Secondary Canvas Support.* That the word "relining" is a misnomer has been mentioned briefly already. "To line" is to apply a layer of material to the inside of an object. The word "relining" has been a most unfortunate choice since the support for the painting may consist of fabric, cardboard, wood or metal, and it is misleading to refer to such supports as "lining."

The providing of a secondary support is considered when the condition of the primary support, be it fabric, paper or wood, has deteriorated and the damage manifests itself as a split, tear, hole or structural failure.

The choice of material for the secondary support can be fabric, wood, plastic panel or metal, and is determined by the size and physical state of the painting. Wood and metal supports are usually heavy. However, there is a new support with a honeycomb construction involving plastic and aluminum which is ideal for securing a painting to a rigid, durable, lightweight, low coefficient expansion support, unaffected by mould, pests or humidity.

The actual operation of affixing the secondary support to the original fabric is a relatively simple matter if the proper tools and material are available, and a few basic rules are kept in mind.

In preparation for affixing the secondary support, the surface of the painting must first be properly restored. All imperfections such as loose paint, tears, holes, cleavage, cupping, cracks, flaking, blistering and abrasions must be repaired and the whole surface varnished to seal all possible cracks in the painting to avoid wax resin seeping through. The painting should then be faced with mulberry paper using rice flour paste adhesive.

A good solid plyboard with a formica top is a very useful work table for repair, mending and original support preparation.

The back of the original canvas is cleaned of all imperfections. This will include removal of old patches, scraping of old adhesives, wax and putty and cleaning of all surface dirt and dust.

Some old paintings have some secondary canvas support attached with wax. This should be peeled off only in narrow strips so

Fig. 7. Folding of canvas over corners.

as not to apply unnecessary strain on the original canvas. In areas where there is some difficulty the wax can be softened with alcohol or mineral spirit. A number of secondary canvases were put down with vegetable or hide adhesive. Due to the complete breakdown of such adhesives with time, it is relatively easy to peel off strips of the old secondary canvas. Some, however, will require special care as the adhesive may have penetrated deep into the original canvas; in this case the old secondary canvas requires scraping or shaving off. The use of mechanical tools such as rotary or orbital sanders is not advisable as the vibrations produced by such implements may adversely affect the ground and paint of the pictures.

The painting with a wood or cardboard panel as its old secondary support offers a great deal of hard work. The original primary canvas cannot be peeled off since lifting or bending of this canvas will split, crack, and ruin the paint; the only workable method is the use of a chisel for the removal of the wood panel in very thin layers, a small piece at a time. In the case of cardboard, a sharp knife can be used, lifting thin layers of small areas. The softening of wood or cardboard with water is not recommended.

When these preparations have been completed, the secondary support (or new secondary support) may be affixed. The primary components required for this work include the stretcher, canvas and wax resin mixture.

Many methods can be adopted depending on availability of materials, tools and equipment, but the quality of the finished product depends upon good tensioning of the canvas and a sufficient amount of wax resin mixture to provide proper bonding with the original support.

Canvas for the secondary support can be linen, cotton or silk, free of knots, clean and of appropriate dimensions. The choice of canvas will depend upon the quality, size and thickness of the original support. Old and thick canvases require heavy secondary support, while a small painting may be supported by cotton or silk fabric.

The canvas must now be stretched. The stretching of any canvas, irrespective of its age, follows standard engineering practice, which allows a proper distribution of forces when the wedges are driven in, to obtain the necessary tension. This applies to any type of stretcher used, fixed or adjustable, or any other wooden support.

Fig. 8. Canvas stretching

The canvas, the dimensions of which are at least two inches larger all around than the stretcher itself, is placed flat on the table and the stretcher positioned over it, the edges of the slats parallel with the canvas weave. One edge of canvas is folded over the shorter slat and one tack hammered in hard in the middle of the slat, as shown in Fig. 8 "A." The opposite side of the canvas is then stretched with the help of pliers and secured to the middle of that

slat. (The arrow shows the direction of tension.) The canvas is then stretched in the perpendicular direction and one tack tapped hard into the middle of the longer slat; finally it is stretched across and secured on the opposite long side with another tack as shown in Fig. 8 "B." The center of the canvas is now stretched along its longitudinal and lateral axes.

The next move is to stretch the canvas tightly over each corner diagonally. As the corners and edges of the stretcher are usually very sharp and may cut through the canvas, they should be rounded with a file and made smooth. If a thin fabric is being used, a thin cardboard or plastic tape should be put over them. (See Fig. 4, page 58.) Diagonal stretching and tack placement is shown in Fig. 8 "C" always working one corner and then the diagonally opposite one. (Also see Fig. 7, page 70, for corner detail.)

Now, starting from the center of the shorter slat, secure the canvas to the stretcher with tacks spaced one and one-half inches apart, always driving a tack in on one side, pulling the canvas with pliers on the opposite side and securing that with another tack. The same procedure should be continued along the longer slats as indicated in Fig. 8 "D."

•*Preparation of Canvas for Impregnation.* One of the most frequently used procedures in the past was the employment of the so-called *fixed-framed assembly.* The stretcher frame itself in this case is fixed solid at all four corners, and its dimensions are bigger by at least five inches all around than the actual painting. The canvas is placed in the middle of the frame and the outline of the painting marked with chalk or felt pen. The wax resin mixture is applied within the marked area.

A second method involves the use of the old stretcher or a new one. As mentioned previously, when employing the old stretcher, all slats and crossbars should be carefully marked during disassembly so that they can be reassembled in their original order. All edges, surfaces, slats, corners and wedges or keys must be inspected for damage and if necessary, repaired, and all tacks and nails removed. Damaged wedges should be replaced by new ones made of hardwood of the same shape and thickness.

Whether new or old, the stretcher should be one-quarter inch smaller in length and width than the frame, so that it fits easily into

the frame recess when all wedges are hammered in, which expands its size.

During the assembly of this stretcher all slats and crossbars must fit together tightly, and, with the help of a square, a 90° angle maintained at all four corners.

To prevent any movement or shifting occurring during the handling and manipulating of the stretcher, two nails should be tapped in half way only at each corner. The heads of these nails should be well above the surface of the slats so that they can be withdrawn easily after the new support is secured on the stretcher. (See Fig. 3, page 56.)

A length of masking tape, preferably plastic, can be placed along all edges of the stretcher so that the new canvas is separated from the wood and no wax resin flows over the slats. This will prevent the canvas binding to the wooden slats.

The outline of the new canvas is made by placing the assembled new stretcher on top, and marking with a felt pen. A line drawn two inches away all around these markings will provide the line of cut. Sharp pinking shears should be used to prevent the edge of the canvas from fraying and separating. Now the actual stretching can begin, as outlined on pages 72–74.

When this is completed, the canvas on the stretcher is placed on top of waxed paper or tracing paper and wax resin applied between the stretcher slats. The stretcher is then turned upside down, the paper removed and the areas above the slats impregnated with wax resin. It is advisable to let the wax resin set in for a few hours.

Remember that the location of the tacks on the canvas and stretcher must be marked carefully so that the infused canvas will be placed back in the same location in relation to the stretcher; this prevents the buildup of wrinkles or folds and helps to retain the same pattern of stresses during the final tensioning.

•*Impregnation.* The basic elements required for successful impregnation of the actual painting or of the secondary support, which may be of fabric, wood or metal, are wax resin mixture, an electric spatula or iron, flat and solid board and wax paper or tracing paper.

One of the most useful tools for spreading wax resin over the surface is a modified light electric soldering iron with a 100 watt tip.

COPPER BLOCK

Fig. 9. Modified soldering iron.

A solid copper block approximately two inches long, one inch wide and one inch thick, has a hole drilled at a 45° angle to accept the tip, which is secured with a suitable screw (Fig. 9).

Temperature is controlled by a Variac. It is impossible to state the precise working temperature required during impregnation, as it will depend upon the composition of the wax resin employed, thickness of canvas used and heat dissipation of the working support. The only figure which can be offered is the melting temperature of pure wax, which is approximately 145° F.

While working with new canvases, this temperature can be increased, but care must be taken not to burn the wax resin mixture because this would produce smoke which might be inhaled.

During impregnation of the actual painting the temperature should be as low as possible and the painted surface well insulated from the working surface with paper. If possible, The working surface should be made of heat-dissipating material to reduce damage to the paint surface.

It must be pointed out again that both surfaces, that is, the

Fig. 10. Useful tools for lifting tacks.

painting and the secondary canvas, must have an even layer of wax resin over them, and in the case of a secondary canvas, full penetration of the wax must be achieved.

•*Lifting of Secondary Canvas Support.* The lifting and removal of canvas from the frame or stretcher is a very simple matter when the proper tools are used. The tacks holding the canvas can be lifted with either a properly shaped screwdriver or sharp-nosed wire cutters.

A three-sixteenth inch wide screwdriver is shaped by filing a "V"-shaped notch in the center. This notch is inserted underneath the head of the tack. One must take care not to damage the canvas, and the screwdriver should be pushed gently from the edge of the stretcher on the side which is away from the canvas proper (Fig. 10 "A").

The second tool may be small, sharp-nosed wire cutters with the pointed edges rounded to prevent cutting of the canvas. This should be used by grabbing the tack's head from the sides and, with light pressure downward, lifting it, always working away from the canvas proper (Fig. 10 "B").

•*Fusing.* Although this operation may appear to be a very complicated undertaking to the novice, with the proper set-up and approach it can actually be a simple one.

The main requirements are vacuum and heat. The professional set-up is a vacuum table with a flat, highly polished work surface and electric heating element embedded in its surface. A control box wired to this heater operates the thermocouple and a timer, therefore the required operating temperature and timing of the heating element can be preset. A vacuum pump connected to the table supplies the necessary vacuum.

There are several designs of such tables available on the market, but they are costly and not every restorer can afford such an installation. The small business, therefore, must adopt other means which can take the place of the vacuum table, and which, with perhaps more effort in work and time, can produce satisfactory results.

The practice of fusing a secondary support to an actual painting has been known through the ages. In Holland, where high humidity played havoc with linen canvases, the technique of fusing was based on heat supplied by several candles located underneath

a copper plate. The beeswax-impregnated canvas was placed on top of the plate, and when the wax became fluid, the actual painting was placed on top of it and covered with a heavy, flat board. To generate the necessary pressure while fusing, a series of clamps and weights were used.

At the end of the nineteenth century restorers adopted a hot iron method wherein a heavy iron, heated over the pot stove or heated internally with chalk cinders, was used for fusing previously wax-impregnated surfaces; the actual painting would be resting face down on a flat bench, with the secondary support on top. During cooling, pressing was achieved by placing heavy stones over a metal plate resting on top of the assembly. Some of the old-timers still employ this method, and although it is highly time consuming, with a lot of experience and practice it does produce satisfactory results.

One can observe in this brief description of methods used in the past that two words frequently recur: heating and cooling.

Even distribution of heat over the whole area of the painting is essential to liquify the wax mixture and produce a proper bond. This can be achieved either by heating the whole area of working support as with the vacuum table; by a gradual buildup of heat by the constant circulation of a hot iron over the area to be fused; or by the use of a metal plate, made of a good heat conductor such as copper or aluminum, placed over the assembly and heated with a hot iron or hot air blower.

Cooling must take place under pressure produced by either weights or vacuum. The disadvantage of using weights is that one very seldom finds a painting which is absolutely flat. There are always raised areas of the surface—brush strokes—which under pressure may be flattened out. Even the use of soft blankets, such as rubber or felt, may not prevent damage to the uneven surface.

A vacuum created underneath the blanket covering the assembly to be fused produces an ideal distribution of force over the whole area of the painting, and this is a primary requirement in the achievement of an efficient bond.

One may construct a vacuum table as follows: Use a half-inch thick plyboard with a sheet of formica permanently bonded to it as an operating support. A sheet of tracing or wax paper is placed over

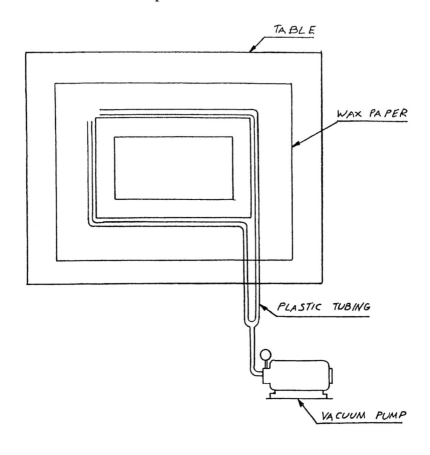

Fig. 11. Layout of a vacuum table.

it and attached at the corners with masking tape, the size of this
paper larger by two inches overall than the secondary support. On
this sheet the painting, already impregnated with protective facing
over its surface, is laid face down. To preserve brush strokes or heavy
impasto, a layer of thin felt can be inserted underneath the paint-
ing. The previously impregnated secondary support is located on
top of the painting; another sheet of waxed paper is placed over the
secondary support and secured to the board at the corners or edges
with masking tape to prevent movement of painting and secondary
support. Two lengths of plastic tubing one-eighth inch in diameter,
with a series of holes drilled along their lengths, are placed around
this assembly, their ends brought outside as shown in Fig. 11, and

connected to the vacuum pump. The recommended electric pump is General Electric Model 5KH32EG with 1/6 HP electric motor. This unit can be used as a vacuum pump or a compressor and both pressure and vacuum are fully controllable.

A hard rubber or plastic blanket is spread over the board and all edges of this blanket sealed to the board with masking tape or any other suitable material.

Within a few seconds of the pump being switched on, a complete seal should be obtained. (This can be determined by watching the gauge located on the pump.) The vacuum produced should not exceed ten inches of water as a higher vacuum application may flatten out brush strokes or raised areas of paint. When the desired vacuum has been obtained, heat can be applied over the area of the blanket which covers the painting, which is easily discernible. An ordinary household electric iron is slowly and repeatedly passed over the area, starting from the center and working towards the outlined edges, making sure that the whole surface is accumulating enough heat to make the wax resin mixture melt. The temperature of the iron should be slightly higher than the actual melting temperature of the wax mixture as the blanket will reduce the heat from the iron. The temperature of the fused surfaces can be checked with a thin steel tube thermometer inserted underneath the blanket. To avoid the hot iron sticking to the blanket, a sheet of ordinary brown paper can be spread over the blanket; this will enable the iron to glide freely over the surface.

The cooling cycle is a very important part of this operation. The vacuum pump should be switched off only when complete cooling has taken place, and the painting left to rest under the blanket for a couple of hours.

Support: Wood Panels

The repair of wood panels requires the application of the best carpenter's technique, fitting, patching, sealing and the adhesive method.

Supports fabricated from different woods and incorporating different methods of assembly require different and specific tech-

niques of mending. Thin, light and soft wood repair necessitates the use of balsa wood, while mahogany and oak can be repaired with softwood.

The damage most frequently encountered is due to warping, splitting, denting and cracking of panels.

Work with warped panels involves a rather long undertaking. First, the panel may have to be taken down in thickness by planing, chiseling or milling, while the front is meanwhile being protected by several layers of paper with the panel itself well clamped to the workbench. Then a linen canvas, previously stretched and impregnated with wax resin, is attached to the back of the panel, which has been impregnated with the same wax resin. As a backing support, two-inch-wide strips of one-half-inch-thick balsa wood soaked in wax resin are pressed, under heat, to the linen canvas. The balsa strips should be staggered and laid parallel to the panel grain. Thin gauze strips are placed on top, and then a second layer of balsa wood strips is laid across the panel grain and covered with heavy linen canvas. (Fig. 12).

Another method involves grooving of the back of the panel. One-sixteenth-inch-wide grooves are made with a router along the grain to a depth of one-eighth inch from the panel front, and after these are filled with wax resin, balsa wood or softwood strips are inserted in the grooves, under heat and pressure, so that the panel is flat again. The strips are planed down to form a flat and even back surface parallel to the panel. Gauze strips are laid across the panel and then one-half-inch balsa wood strips are pressed in, and all is finally covered with thick linen canvas.

Light warping and panel splitting can require a cradle, usually made from hardwood strips. First the panel is slotted along the grain to take cross-strips; then these strips are placed, with adhesive, along the panel grain, and another series of strips is slid underneath, across the grain. The second lot of strips is not secured to the panel and is only pressed down by the first lot, thus providing for contraction and expansion of the panel.

Thin wood panels can be flattened by applying moisture to the back of the panel and drying under pressure, carrying it from light pressure at the beginning to heavy after a few days. When flat and dry, the back of the panel should be brushed with wax resin.

Cracking of wood panels is relatively easy to repair. Deep, wide

Fig. 12. Balsa wood — canvas support.

cracks in the front of the panel are filled with gesso and wood putty, arriving at the required thickness by a very gradual buildup of thin layers; each layer has to be completely dry before the successive layer is applied.

The worst damage to paintings on wood panel is due to lateral shrinkage or loss of width across the grain, resulting in the surface being compressed laterally and the lifting and pull-off of the paint. Such damage, called *cleavage*, is very serious as it is usually accompanied by the edges of the paint gradually curling upward and buckling, which pulls the paint away from the panel.

In such a case each individual damaged paint area must be attended to, first by an application of hot wax resin underneath and around the lifted part, and then by gentle pressing placing it in the right spot. This operation involves working with a very fine, shaped, hot spatula directly over the paint and varnish, using as little heat and pressure as possible.

Only when all the damaged parts are reconstructed, and the surface is flat and even, can renovation of the surface commence.

Support: Paper

Any repair or reconstruction of paper support requires a long-fiber rag paper, similar in weight to that of the painting. It is essential that the expansion and contraction of both the support and the paper used for repair be the same. The use of fabric should be avoided because the texture of the weave might be impressed upon the surface of the paper.

The paper support should be brushed thinly and evenly with paste adhesive, the paste diluted as little as possible so that the painting proper is not damaged by water flow.

The preservation of paintings on paper requires the use of proven and reliable adhesives, backing and other materials.

The most frequently encountered damage is due to:

1. Weakening of the original paper support.
2. Formation of tears.
3. Warping.
4. Creases and folds.

5. Damage from being rolled, particularly those papers which have a definite paint film that is buckled, flaked and strained.

6. The existence of grooves, wrinkles, bulges or uneven shrinkage.

7. Air pockets forming between paper and its secondary support where an adhesive has come loose.

8. Foxing as a result of impurities in the paper or the growth of mould.

9. Swelling and shrinkage of the adhesive.

10. Stains from wooden supports.

It has already been pointed out that any work with paintings executed on paper requires a lot of patience as well as the proper tools, equipment and materials. It is beyond the scope of this book to give detailed instructions on how to handle fragile, thin and aged paper. This may require another volume dealing specifically with the problems of paper conservation and restoration. Thus only an outline of damage and repair is given here.

It may be of interest to mention that any temporary repairs should definitely exclude the use of adhesive tapes, labels or any other materials which incorporate an acrylic or plastic base. Rice-flour paste and thin Japanese paper are the only materials for a quick and temporary repair.

Support: Cardboard

Damage to cardboard support usually comprises cracks, dents, breaks, tears, warping, wrinkling, worm holes, stains and rot. Most of the damage is concentrated around the edges of the support, encouraging chipping, cracking and flaking of the paint. Moisture penetration and rapid drying produce twist and distortion of the surface, resulting in weakening of the surface layers of paint.

Separation of board layers is one of the most troublesome damages sustained by cardboard. This happens when there is improper impregnation and pressure applied during board fabrication.

Damage to the back of the support—wrinkles, bulges and

dents—introduces changes in the top surface which affect the ground, paint layer and varnish.

In the case of serious damage or decay to cardboard supporting a painting on canvas, the cardboard should be eliminated. If the painting is on canvas glued to the support, the only method which could be employed with some chance of success is to remove layer after layer of the board with a chisel, scraper or knife. During this operation the painting should rest on a flat panel, face down, held firmly with clamps to the panel, to prevent sliding and damage to its surface. The use of water to separate the canvas from the damaged board is not recommended.

Very few paintings are executed directly on cardboard; usually there is a layer of paper with paint on it. If the cardboard is damaged, the paper will have to be taken off the cardboard support and a new support provided. Such an operation should involve separation of cardboard layers in very small areas and thin layers.

Support: Metal

In the past a number of paintings have been executed on zinc, copper, tin and lead plates. Metal supports were quite common in the Far East as well as the continent of Europe. Scenes painted with oils on metal supports have survived exceptionally well. Most of the metals used have a low coefficient of expansion; therefore the paint dries out and solidifies on a very stable base support. Humidity changes do not affect the metal used, and its exceptional toughness compared with canvas or cardboard contributes to a satisfactory condition. One might expect a lot of corrosion or chemical reaction between metal and paint; however, most paintings show no such effect at all.

The problems encountered are *chipped paint,* which can be repaired by filling in the missing area with an acrylic filler and inpainting with egg tempera; and *deformation of the support,* which is usually in the form of dents and bent edges.

Repair of dents in metal is one of the most difficult and highly skilled operations the restorer undertakes. The strain imposed in the area of a dent results in the metal being deformed by the force which caused the dent. In other words, this part of the metal

becomes disturbed in its basic composition; trying to force it back with sudden blows of a hammer will only result in further damage, which may also impose vibration and cracking of paint in other parts of the painting.

The only method recommended is the use of a press or clamps, with a very gradual application of pressure. The surface of the painting must be protected with a hard board, and then a thick plywood or solid panel placed on top, while the metal support rests on a solid, flat rubber base. A slow tightening of the press should take place over a period of several days to minimize the stress imposed by the action of the press. A hard rubber insert, bigger in size than the dent itself, may be placed over the dent, covered with a flat wood panel, and pressure applied again, watching the flattening of the support after each tightening has been applied.

The procedure for infusion of a painting to metal or plastic support is very similar to that used for canvas supports. The metal or plastic must have one surface well scoured with a sharp tool or heavy sandpaper to enable the wax resin to achieve proper adhesion. The amount of heat necessary for a perfect infusion will depend upon the thickness and conductivity of the material chosen for the secondary support.

In case it is required that the metal or other solid support be placed over a stretcher, canvas-lined adhesive tape can be used; one-eighth inch of such tape should be placed along the edges of the painting and the rest of the available tape folded over the stretcher.

Ground

Ground is the foundation of a painting which is put over the support, to accept paint. Many compositions of grounds are used when laying the base of a painting. To help with classification let us call grounds used in the past *old grounds,* and those used today *new grounds.*

The compositions of old grounds were *white powdered chalk* and a very weak adhesive; *gypsum* and animal adhesive; *white pigment* mixed with chalk and linseed oil; a *combination* of animal adhesive, applied first to the canvas, cardboard or wood panel, and, when this was thoroughly dry, a coat of a mixture of whiting and

linseed oil. These materials were usually applied with a brush, and a smooth and even coat was maintained by sanding.

The new grounds consist of *gesso,* prefabricated and packaged in glass or plastic jars, available in all art shops.

One often sees canvas, paper or cardboard supports that have had an application of water-based size. This, in combination with aqueous grounds, causes much of the deterioration in old paintings. Most of the cracks seen on very old paintings result from the ground drying out; these cracks extend upwards towards the surface, cracking the paint and varnish and therefore loosening the surface. Cracks of this sort, seen on paintings done on canvas, cardboard, wood and metal supports, are a major cause of damage.

Generally, there is a tendency to look upon a painting as an object with a solid support, canvas, wood or metal; in reality, however, metal expands and contracts, wood panels dry out and shrink or swell, and canvas is in constant motion due to temperature and humidity changes. These movements are seldom detected by the viewer or the owner of a painting. Ground with no adhesive power in its structure cannot withstand these movements and thus separates and cracks.

Water-based grounds provide stiff and very brittle layers, and those based on linseed oil oxidize rapidly and also form brittle layers; the result is breakage and granulation, which is also accelerated by the effects of dampness or mould. The ground may break away from the support and is usually pushed up, and if such cleavage happens over a larger area, pieces of ground and paint fall off.

Any repairs to the ground become very tiresome; sometimes it is difficult to get down to the ground level and apply the new ground mixture. In case there is a lot of paint lifting off the ground and the cleavage level is high, the only remedy is to transfer the painting to a new support.

Occasionally some repairs can be performed by infusing or injecting ground mixture through slits and openings in the paint layer.

In the case of a painting on a canvas support, it is sometimes possible to force a wax resin mixture through the back of the canvas. With adequate pressure and heat the lifting paint may be flattened and forced back to the support. Such an operation requires a lot of

patience and time as the manipulated area needs the application of weights, cooling down and examination at each phase of work.

Repair of Surface Damage

The repair of a painting's surface requires some basic preparations to prevent damage during handling, mending and renovation. Irrespective of whether the painting remains on the stretcher or is removed from it, during repair it should be well supported on a solid base.

In the case of the canvas being loose and off the stretcher, the working panel placed under it should be at least three inches bigger all around than the actual painting, and any manipulation such as moving or rotating should be by means of the panel, to which the painting is attached with adhesive tape.

A painting still on the stretcher requires the insertion of a thin metal or stiff plastic plate between the stretcher slats and the canvas, underneath the working area, to prevent unnecessary straining of the canvas during work. This plate should also rest on a solid panel which will provide a rigid support underneath the full area of the painting.

The surface of a painting usually consists of a two main layers: top surface varnish (outer layer) and paint. Damage to the surface usually encompasses both layers.

The outer layer, often referred to as the surface coating, may be a wax layer, consisting of beeswax, paraffin, kerosine or carnauba; a varnish layer, consisting of hard surface amber or copal, or soft surface mastic, damar or sandarac; or an oil layer of linseed, walnut or poppy seed.

Deterioration of the outer layer may assume the following forms:

•*Discoloration.* This can be due to accumulation of dust, smoke from the fireplace, tobacco smoke, air impurities, very fine sand and particles of soil and pollen blown by the wind, and general darkening due to oil and other ingredients in the varnish.

Removal of surface dirt and grime is a relatively simple process. One of the safest chemicals used is benzol, applied with a soft paint brush on small areas of the painting; when the surface is soft enough

it can be cleaned of dirt with cotton wool. Areas which prove difficult to clean can be warmed by an electric bulb—no more than 60 watts power—held about six inches above the benzol-wetted area. Another, more powerful substance used is beeswax paste to which a few drops of ammonia have been added when the wax was in a fluid state. Again, application is with a brush and removal of grime with cotton wool.

•*Clouding (Bloom)*. The effect of humidity on the varnish layer manifests itself in a loss of transparency and a milky appearance of the painting. This is mainly due to the disintegration of the varnish layer, which dries out and breaks up in the form of very small cracks unseen by the naked eye. The varnish coat becomes very fragile and unstable and leaves whitish marks at the slightest touch.

Renovation can be by means of cotton wool swabs dipped in turpentine to which a few drops of linseed oil have been added, or by application of varnish diluted with turpentine. This can be used only as a temporary means of preservation. For a permanent repair, all varnish should be removed and a new coat applied.

•*Blanching*. During removal of varnish some areas of a painting may take on the appearance of matt and whitish splotches. In these areas the details of the painting may be completely obscured. This damage is due to the fast evaporation of the media used during varnish removal, where a certain amount of the original varnish is left over. Also, some chemicals used in the manufacture of paints and ground preparations may also contribute to this blanching effect.

The deposits left in blanching can be removed with cotton wool swabs dipped in turpentine. If the paint itself is blanched, it can be improved by rubbing linseed oil into the area of blanched paint, with the fingers, continuing to rub until all traces of blanching are gone. Remnants of linseed oil must then be removed immediately to prevent discoloration.

•*Crazing*. A pattern of miscroscopic cracks appearing in the layer of varnish on a painting is mainly due to the improper preparation of the varnish, which results in a loss of bond between the basic granules of the materials employed. Also, if the paint layer is not properly dry when varnish is applied, some of the varnish granules adhere to the paint, and when the varnish dries out and cracks it also

cracks the paint. Aging and drying of oils is usually the main cause of crazing. The only remedy to improve the appearance of a painting is retouching and revarnishing.

We turn our attention now to repair of the paint layer. As oil paint was and is of primary importance because the majority of paintings were executed in this medium, these suggestions involving repair to the surface will be dealing with oil paints.

The oil used in paint may be poppy seed, linseed, walnut, or nut oil, or pale or dark drying oil mixed with any of the above. There may also be some spirits of turpentine, petroleums, copal, damar or mastic varnishes, siccatives, or other materials present, without counting numerous patent or secret preparations.

Any of these paints may be damaged and require repair. The paint itself, which forms part of the surface, may be subjected to considerable mechanical and chemical damage. Mechanical damage may be by flies, scratches, dents, breaks, worms, burns, dust and overpaint. Chemical reaction, active at all times, may result in discoloration, fading, darkening, bleaching and chalking.

The general approach to the repair of paint is first to remove all inpaints added to the original painting, secondly to fill in all the paint losses, to preserve the continuity of the surface. The damage mentioned above is addressed in various ways, as follows:

•*Discoloration.* Discoloration of pigments contained in the paint cannot be repaired; the only restorative measure which can be employed in this case is glazing.

•*Fly Spots.* Fly spot removal introduces a lot of work as the spot concentration is usually on a light surface. The excrement of flies is brown and, due to its acidity, reacts with paint, producing pits in the paint due to its etching action.

•*Cracks.* Some of the most disturbing damage seen on paintings is the formation of regular pattern cracks or an irregular crisscross network. Many reasons can be found for the cracking of paint, including *drying* of binding medium; *method of application* of paint layers; *drying rates*; *thickness* of paint applied; *interaction* between paint and ground; and *instability* of support used.

•*Cleavage.* This is a total of partial breakdown of paint into small particles in certain definite directions, caused by movement of the support due to shrinkage or expansion. The ground breaks

away from the support, and so does the paint, which has a tendency to curl upwards round the broken edges, forming concave zones and leaving small pockets underneath.

If the painting is executed on canvas, the cleavage may pull areas of canvas upwards, producing deep channels which are well visible on the back of the canvas. These channels introduce a lot of strain on the canvas, weakening it and often breaking its fibers.

The repair of cleavage can be a very big undertaking. The damage affecting varnish, paint and ground is very difficult to repair as the substance used to adhere breaks in the surface has to be forced into the pockets underneath the separated areas. Application of a vacuum underneath the canvas is sometimes helpful while brushing adhesive directly into the pockets formed by the cleavage. The operation requires very careful and gentle handling of the brush because the paint around the breaks may be loose and flaking, and may be lost forever.

•*Buckling*. Bends, bulges or kinks observed on the surface of a painting usually come from a strain acting on paint and ground, and this comes from the outer coating, particularly when this is made of hard varnish. Because it is directly exposed to air, the resin of varnish dries and oxidizes more rapidly than paints and grounds. This causes shrinkage of the outer layer which, due to its strong adhesion, pulls the underlying paint layer with it, forming ridges of curls and scallops. These ridges show open cracks with large pockets formed underneath the paint and ground, sometimes extending right down to the support.

The repair method is similar to repair of cleavage, but the buckled paint should be softened with turpentine to reduce damage to the paint. Gelatin solution or wax resin mixed with gum elemi provides a good binding agent.

•*Cupping*. Some deformation of paint takes the form of a cuplike shape and is mainly due to water seepage over the canvas. Wet fibers of canvas weaken and decompose the grounds which swell, pushing paint and varnish upwards. In later drying the paint separates, and the edges of the separation dry out first, producing a cuplike effect.

Repair is a slow and lengthy undertaking as each damaged region of paint requires individual attention. Steam and a flat-

nosed electric iron, warm to the touch, manipulated gently over each deformed spot, should depress and flatten the paint down. Any manipulation of the hot iron must be over greaseproof paper so that the iron never gets in direct contact with paint or varnish. It is a good idea to leave this paper on the surface until complete cooling has taken place.

•*Flaking*. Loss of adhesive power and bond in the cracking of paint, ground and varnish is usually accompanied by detachment of small areas of surface from support. This is mostly due to extremely fat paints having been used and applied thickly.

Mending, or rather reattachment, can be carried out from the front of the painting by working in some adhesive, preferably wax resin, with a hot iron, through mulberry paper. This very painstaking business is normally undertaken only when small areas of surface are affected.

Another method is to introduce the adhesive from the back, through the canvas, working inch by inch through the whole of the canvas. However, it may on occasion be necessary to go over the front of the painting again to reattach flaking paint where the adhesive has not penetrated the canvas.

It is advisable, when working with a hot iron tip, to keep it away from the surface but close enough to warm and soften the flaking paint. After a few drops of melted adhesive are placed over the flake, it can be pressed down with a wooden spatula, through wax paper. On no account should the hot iron tip be in contact with paint as disintegration of paint will follow. A small weight should be placed over the flake to keep it down. It is useful to use transparent paper during this operation to enhance observation of progress.

As soon as the mended area is cool, the excess remnants of wax resin on the surface should be removed immediately, using cotton cloth or cotton wool moistened with turpentine or mineral spirit. All traces of turpentine should be wiped off the surface to prevent weakening of wax resin and paint.

•*Wrinkling*. This is found on some old paintings in the form of ridges, usually consisting of hard paint. These disfigurations are mostly due to an excess of oils used in the paint preparation.

Flattening of these wrinkles with pressure does not solve the problem as it is most important to retain and preserve the texture

and brush strokes of the surface. Heating with a hot iron tip and gentle smoothing with a wooden spatula worked over the paper may eventually eliminate these distortions. By careful manipulation of a warm toothpick some brush strokes can be brought back to the surface.

Blistering. There are two main causes for paint blistering: excessive heat, direct or radiant, and fresh paint lifting off the ground.

Blisters formed by excessive heat are usually very brittle as any oil or binding medium is destroyed by the heat; they should be treated with appropriate care. First of all, low-viscosity oil can be spread over the blisters with a very soft paint brush, repeated over a period of several days. This should be protected by plastic sheeting to prevent oil evaporation. When softened, the blister can be punctured with a sharp needle which has been heated over a flame and cleaned with a rag to prevent any carbon deposit created by the flame being deposited on the paint surface. Diluted or melted wax resin or gelatin can be forced through the puncture hole, either by hypodermic needle or the vacuum technique. The blister should then be pressed down gradually by the application of heat and light weights.

Pentimenti. Thinning of the paint layer or wearing of the paint allows dark outlines, left during sketching or underpainting by the painter, to show through. These outlines are referred to as *pentimenti*.

The paint may become very translucent due to aging and therefore more light is transmitted through it; any alterations in the design carried out by the painter then become clearly visible.

As the final layer of paint is worn out, the only remedy to improve the appearance is to overpaint those areas. However, in many cases it is better to leave them alone to preserve the originality and authenticity of the painter's work.

Abrasion. Damage inflicted to the surface may extend deeply through the outer layer of varnish and affect the paint layers as well. Scratches and dents are the most difficult to repair; the layer of paint, in addition to being grooved, is usually badly torn along the scratch, leaving ragged edges with the paint lifting along the line of the scratch.

It is quite a job to bring the surface to a uniform and perfectly flat condition. If the support is undamaged, filler can be applied to the grooves of the scratch, particular attention being given to the choice of filler. Some scratches may be fairly shallow; thus the filler should possess high adhesive power so that no lifting or removal of filler from the scratch line takes place during the scraping-off operations, necessary to get the surface flat and to make the scratch invisible.

•*Filling.* Any hole, crack or cavity in a painting should be filled to prevent further damage and to reinforce the edges of holes and cracks, seal them against dirt and moisture and provide a smooth, even surface.

In old paintings, the filling often covers some of the original paint. In such a case the paint must be uncovered and the filling replaced or resurfaced.

It is of major importance to use a proper filling mixture for mending openings in the surface. The filler must be pliable to make it easy to apply and must bond easily to the adjacent material. It should look like the original surface, and it must be durable. One of the most suitable mixtures consists of two parts whiting, one part stand oil (hot), appropriate pigment, fish- or hide-based adhesive, with zinc white and wax resin to be added in small quantities. No synthetic adhesives should be used. When kept in a sealed container this mixture will last for a long time.

The filler is pressed well into the hole and then smoothed and made even with the surrounding surface. Texture of paint and brush strokes can be simulated and left to harden. A light coat of varnish can then be applied to prevent paint from soaking in.

The application of any filler must be very gradual, involving several thin layers until the level of the surrounding paint is matched. Too great an application will necessitate the scraping of filler which has already hardened, damaging paint which is in the vicinity of the cavity. However, if this does become necessary, an appropriately ground scraper should be used, with movements towards the operator. If the scraper is pushed away from the person using it, digging in cannot be avoided. A very light hand, always resting on a solid support, may prevent unnecessary damage.

•*Previous Reconstructions.* One of the most troublesome and persistent problems in the work of the restorer is the removal and

elimination of inpainting and overpainting placed on the surface by previous restorers. Some of the inpainting by heavy layers of paint mixtures becomes very hard and stiff, requiring mechanical means of removal, such as scraping or sanding. Mostly the inpainting covers areas which have been patched up with various fillers such as bread, papier-mâché, putty or plastic fillers. A number of these disintegrate in time, producing cracks in the paint or discoloring it. Some of the inpaint, after drying out, separates from the ground, forms a big blob and flakes off.

Pigmented varnish, overpainting and repair to grounds cause a multitude of headaches as the ingredients and techniques used to mend and repair damaged parts are usually unknown and no records of the work performed are available.

Usually a stained and pigmented varnish, brittle and hard, covers the whole surface; some of it is imbedded deeply into the brush strokes of the paint itself, but quite often the varnish was mixed with paint to cover imperfections encountered on the surface. Removal of these varnish layers can be performed using a solvent based on two parts acetone and one part diacetone alcohol. Application may be by a soft brush or very gentle rubbing in a circular motion with cotton wool. The remnants of solvent must be removed immediately with turpentine.

Overpainting — previous reconstruction of areas where there was a loss of paint — can be identified by a difference in style, brush strokes and paint raised above the surrounding surface. There were many reasons for overpainting, such as hiding unwanted objects, objectionable parts, the addition of new colors or new signatures, and covering overcleaned areas.

The paint used in overpainting may consist of different ingredients and can build up a new surface of different hardness. Generally, this new paint sets very hard and introduces problems in removal because in some cases it covers the unspoiled paint areas, and in the attempt to remove it, using strong solvents, the undamaged paint is being affected too.

A solvent based on acetone, diacetone alcohol and a few drops of ammonium hydrochloride may soften the overpaint, but in the case of a tough layer a scraper has to be used.

Renovation

Surface Renovation

There are several reasons for surface renovation of paintings: to reveal the design and color, to prevent damage to the paint layer, and to replace deteriorated varnish by varnish which will better protect the painting and permit more effective structural treatment of the surface.

The first principle of renovation is to interfere as little as possible with the original painting, and only the original appearance should be recovered. Any repair, be it mending, filler, paint or varnish applied, should be easily removable if required.

Any picture requiring varnish removal should be subjected to a complete renovation operation; all existing varnish, inpainting and accretions should be removed.

Before any attempt at renovation is undertaken, color photographs of the front and back of the painting should be taken. It is surprising how quickly one's memory fails as to details of the original condition, appearance, colors and general assembly. These photographs must be sharp and absolutely accurate and should be kept as records of renovation.

All details of renovation should be methodically recorded. Such records, in addition to the photographs, should include a full and detailed outline of the actual work, method, paints, varnish and solvents used, as well as the physical state of the surface. If possible, the technique of painting, paint and varnish used by the painter should be incorporated in the report.

One of the first tasks to be carried out is a thorough examination of the surface of a painting. The outer layer of varnish, its state and composition should be established by means of a detailed examination with:

1. A pocket lens held parallel with the surface—this may reveal irregularity of the surface, build-up of varnish, brushstrokes, inpainting and surface repairs.
2. Binocular magnifier—used mostly for examination of large areas.

3. Unaided eye—with the help of a strong light, direct or tangential, which will disclose the general state of the surface, such as tone and color, irregularities and deteriorations.

4. Ultraviolet light—which is ideal to reveal all inpainting, repair and alterations.

5. Infrared light—which penetrates deeply showing grounds, underlay and condition.

6. X-ray examination—which reveals losses of paint, damage to paint, and hidden preliminary attempts of the artist, and even whole paintings which have been entirely overpainted.

After examination, the first stage of renovation is usually the removal of surface dirt, grime, dust, soot and smoke deposits.

Dust removal is by either a feather duster, very soft brush or soft cloth, with a vacuum cleaner intake nearby so that the dust is not spread all over the studio. The back of the support should be cleaned of dirt, stains and cobwebs by the use of either rubber erasers or powdered rubber. No liquid of any kind should be used on the back of the canvas—only dry cleaning is recommended.

Some dust may be imbedded in the top varnish layer, having settled there during varnish application. This can be removed only by complete varnish elimination.

White spirit or mineral spirit on cotton wool can be applied to remove grime from the surface after the first dusting. During this operation, the board, panel or canvas must rest on a firm, solid support, so that no damage is inflicted during cleaning operations. While working on the back, a sheet of paper should be inserted underneath to prevent the surface coating from being scratched.

One method of surface renovation is to dissolve the surface coating with a solvent and then pick it up with a cotton swab which has been moistened with the same solvent. Another method involves liquifying the coating with a solvent and picking it up with a cotton swab which has been moistened with an inactive liquid such as turpentine. The coating may also be swollen or gelled with one solvent and picked up or rinsed away with an inactive liquid.

It has to be understood that the difference in solubility of the paint proper and the surface coating is a function of the speed of solvent action and the length of time the solvent is allowed to act.

The mechanics of renovation, then, should follow this pattern:

1. Remove surface grime and dust.
2. Reform surface coating.
3. Dissolve coating in areas defined by the design of the painting.
4. Flood the surface with an inactive liquid and then apply the solvent.
5. Use a mixture of various weak solvents by reducing the rate of solvent activity with the help of inactive liquid (turpentine or naphtha).
6. If necessary, warm up surface coating and dissolving liquid.
7. Take off coating by layers, by repeated operations instead of removal all at once.

•*Solvents.* The use, choice and application of solvents is based on laboratory and experimental work conducted over the past years. There is no magic formula with a general application. Each painting is different in surface construction, exposure to environment, wear, decomposition, storage and handling; therefore each painting requires a different technique of renovation.

The main concern is to establish a solvent which will soften the varnish but not affect the paint. This can be done only by positive testing of the solvent on the edge of the painting or on small areas of the painting, as the response to the solvent may be different in various areas of the surface.

The test should commence with a weak solution of solvent, gradually increasing in strength to the appropriate grade. The most frequently used solvents are acetone and isopropyl alcohol in various concentrations. White or mineral spirit is used as dilutants to obtain the correct strength. Other solvents used are ammonia, ethyl and methyl alcohol, toluene, turpentine and xylene.

The basic idea of solvent usage is to break the tightly assembled molecules of varnish and at the same time to avoid solvent action on the paint itself, which would cause the paint to swell or disintegrate, causing damage known as *leaching.*

Volatility—the evaporation speed of the solvent—is the important factor in a solvent's action; during varnish removal, the higher the speed of evaporation of a very strong solvent such as acetone, the less effect there will be on the paint. Any strong solvent with low volatility may have a disastrous effect on the area to which

it is applied. As the physical and chemical composition of paint is entirely different from that of varnish, the effect of solvent reaction will be different too.

It may be of some interest to know that the evaporation of acetone is three times faster than methyl alcohol and four times faster than ethyl alcohol.

The volatility of the most frequently used solvents can be categorized as follows:

Very slow: mineral spirits, xylene
Slow: ethyl alcohol, toluene
Medium: methanol
Fast: acetone

Comparing the dissolving property of solvents diluted with mineral spirits, we get the following continuum (from the fastest, at top, to the slowest, at bottom):

Fast: Acetone 1 part — white spirit 3 parts
 Ethanol 1 part — white spirit 12 parts
 Isopropyl alcohol, pure
 Acetone 1 part — white spirit 1 part
 Acetone 1 part — white spirit 2 parts
 Ethanol 1 part — white spirit 8 parts
Slow: Ethyl alcohol 1 part — white spirit 4 parts

In addition to volatility, the restorer must consider the *strength* of solvents. The ability to dissolve varnish can be classified as:

Mild: petroleum distillates, mineral spirit,
 turpentine, rectified paraffin
Medium: xylene, toluene, benzene
Strong: alcohols — butyl, isopropyl, ethyl, methyl
 esters — methyl, ethyl, butyl acetate
 ketones — acetone
 ethers — diethyl ether

Each painting will require its own solvent and solution. Many recipes are available, and the choice of one is up to the restorer. Some like to start with acetone and its solutions, some with alcohol.

The reaction of varnish to the solvent is unpredictable and that is why experience, feel and "know-how" play such an important part. Varnish based on alcohol will require a different approach from that based on oil. Detection of this differential comes only with practice.

Let us now consider the common solvent ingredients individually.

TURPENTINE. Obtainable on the market under the name *Gum Turpentine*, it is one of the best solvents for renovation, dilution of paints and varnishes, and for brushing on the paint surface before inpainting to avoid trickling and provide a better adhesion. It is sold by art shops in a very pure state, doubly distilled and purified, under the name of *Rectified Spirits of Turpentine*. This product is exceptionally good, but expensive.

The chemistry of turpentine shows that it has a tendency to fall back to the resin state from which it was produced, when exposed to light and air. This is noticeable on the neck of a turpentine bottle in the form of a sticky, dark brown film. Only the best turpentine procurable is fit to be used on oil paintings.

MINERAL SPIRITS. The name is a generic term for petroleum distillate, which resembles turpentine in all its chief characteristics. The trade names associated with these products are *paint thinner*, *naphtha* and *varnolene*. While turpentine develops rosin during the aging process, and becomes viscous, no changes occur in mineral spirits. Some restorers prefer using petroleum distillate for softening varnish layers and cleaning brushes.

Mineral spirits were used as a painting medium in very ancient times; they are being rediscovered now and, because they evaporate completely, they are coming into favor with certain painters.

XYLENE. This product, under the trade name of *Xylol*, is derived from destructive distillation of coal tar. In general, the dissolving power of xylene is considerably superior to that of turpentine. Due to a very slow evaporation rate, this product is one of the most helpful ingredients in renovating paintings. It is, however, inflammable and highly toxic to the human body if steadily inhaled in high concentration.

ALCOHOL. Wood alcohol, methanol, ethanol and shellac solvent, which are all anhydrous liquids, are very powerful agents when used in the cleaning of paintings.

DIACETONE ALCOHOL. This is an outstanding, relatively slowly evaporating cleaning liquid; it mixes completely with water and with most organic solvents. However, the petroleum hydrocarbons will not mix with diacetone alcohol.

SAPONIN. This product belongs to a group of glucosides characterized by their property of producing a soapy lather. Commercial saponin is a mixture of saponins extracted from soapbark as a white, amorphous powder, and used as a foam producer in detergents and emulsifying oils.

A teaspoonful of saponin in half a pint of water removes surface dirt, smoke film and other impurities in instances where other powerful solvents may prove to be ineffectual.

SUMMARY OF USEFUL SOLVENTS

1. *Acetone:* good solvent for aged paintings, but rapidly affects oil paints incorporating resin base.

2. *Ammonium hydroxide:* very strong, active medium. When mixed with acetone, reduces acetone's activity.

3. *Carbon tetrachloride:* effective on wax coatings and most of the hard, natural resin coatings, acting very slowly.

4. *Cellosolve acetate:* dissolves most of the soft natural resins. It has a very slow effect on aged oil paint. Extremely useful coupling agent for hydrocarbons, alcohols and ketones.

5. *Denatured ethyl alcohol:* strong and of rapid action on natural resins.

6. *Diacetone alcohol:* dissolves most natural resins.

7. *Ethyl alcohol:* good for resin coatings.

8. *Ethylene dichloride:* excellent for soft resin coatings.

9. *Kerosine:* similar action to naphtha but very slow evaporation.

10. *Methyl alcohol:* strong, active solvent of most resins.

11. *Mineral spirit:* slowly evaporating liquid, used as inactive media.

12. *Morpholine:* used on oil coatings; slow acting, very useful on gold leaf, egg tempera.

13. *Naphtha:* very effective wax solvent, does not affect polyvinyl acetate or natural resins.

14. *Pyridine:* good for removing stains on paper.

15. *Toluene:* effective on wax, polyvinyl and hard natural resins.

16. *Turpentine:* good wax solvent, does not affect polyvinyl acetates or natural resin coatings or aged oil paint. Does leave a residue after evaporation, which can be removed with naphtha.

Occasionally solvent solutions based on acetone or alcohol may fail to disintegrate coatings, therefore the following formulas may be of some help:

1. 4 parts benzol, 3 parts fused oil, 1 part alcohol.
2. 4 parts hydrochloric acid, 1½ parts bleaching powder, 5½ parts turpentine.
3. 10 parts soap, 7 parts potassium hydrate, 2 parts potassium silicate.
4. Benzene mixed with alcohol will dissolve most artificial resins.
5. Turpentine and ammonium.
6. Alcohol and ammonium.
7. Alcohol and kerosine.
8. 2 parts petroleum naphtha, 2 parts carbon tetrachloride, 1 part xylene, 1 part diacetone alcohol.
9. Pure xylene.
10. 2 parts acetone, 1 part diacetone alcohol, 1 part kerosine.
11. Asphaltic bitumen coating, used in the past for some European paintings, can be removed safely using carbon tetrachloride with petroleum.
12. Removal of grime can be accomplished by using equal parts of turpentine and naphtha or alkaline wax emulsion.

•*Varnish Renovation.* There are several methods being used in varnish renovation: *reforming, regeneration* and *complete varnish layer removal.* Each method depends upon the condition of the outer surface. Varnish can be removed by solvents, vapours, rubbing or scraping.

Reforming, which is improvement and amendment of the surface coating, is employed to correct surface cracking, crazing, bloom, blanching and dullness, allowing the original varnish to remain. Reforming allows removal of the coating's tension, makes it more homogeneous and enables the coating to be easily dissolved in case complete varnish removal is necessary.

When the outer layer of varnish has been cleaned of dust and grime, it can be sprayed with a strong, slowly evaporating solvent, for a period of a few seconds, to allow the varnish layer to soften and become tacky. The solvent has to evaporate completely, which usually takes a few hours, then, and only then, can the actual reforming of varnish be undertaken. This can be done by rolling

over the surface with a swab dipped in a weak solution of solvent such as toluene or one part acetone to five parts white spirit. The reforming method allows the varnish to swell by breaking the molecules, but has little if any effect on most paints.

Another method which may be used in the softening of the varnish layer is *regeneration*. The painting is inserted under a tent made of plastic sheeting which is sealed to the base. Alcohol or acetone is poured into a flat dish and inserted into the tent so that as the liquid evaporates, the vapor stays within the tent. Within a couple of hours the varnish will be soft enough to be renovated, either by worked-in diluted alcohol with a soft brush all over the surface, leaving the existing varnish on the painting and if necessary applying a thin layer of a new soft varnish over the existing one, or by complete removal.

The disadvantage of this method is that some paints have a tendency to swell too, which makes varnish removal dangerous.

The third method is *complete varnish removal*. One of the oldest techniques of complete removal is by means of a wad of cotton wool dipped in a cleaning solution and wiped over the surface, with a steady, circular motion. No pressure is exerted on the wad, which should glide lightly over the surface. This technique requires a lot of practice and patience. Too much solvent on the wad will deposit the solvent over a large area, softening varnish in patches, and leaving sticky patches covered with bits of cotton wool; not enough solution, or fast movements of the hand, will result in little effect.

At any time that any renovation is undertaken, a quantity of pure turpentine and a spare cotton wad must be available in case of emergency, and as soon as any paint is picked up, that area must be neutralized with turpentine.

Positioning of a painting during renovation is immaterial; it can be vertical, horizontal or at a slight incline. What is important is the positioning of the light source, which should concentrate its rays directly onto the work area.

Whatever the method or technique adopted, considerable care must be exercised in manipulating cotton wool wads or swabs. The surface of the painting should never become too wet, and no cleaning solution should be left standing in the form of drops or pools. Each area cleaned must be dried completely.

The use of a cotton wool swab on a stick is recommended on difficult areas, and again there should be no applied pressure while it is rolled over the surface.

When heavy ridges of paint are part of the surface, some varnish may be imbedded in them or in the grooves between the paint; these can be removed with a long-haired brush or a toothpick.

Light rubbing with one's finger over a drop of solvent, which has been applied with a small brush, dissolves the varnish, which comes off in the form of small granules. This is a messy undertaking but, in some cases, absolutely essential as the amount of rubbing required can be felt with the most sensitive part of the finger, and the radiation of body heat accelerates the softening of varnish and its removal.

•*Paint Layer Renovation.* We will now turn to renovation of the paint layer, as well as some accompanying special considerations of varnish renovation, on the various supports: fabric, wood, paper, and metal.

FABRIC SUPPORT. Water-based color, a pigment mixed with water, was employed in very early stages of art as a paint which was brushed on silk, skin and leather. This technique is still being used and is very common in the Far East. Several examples of such work are available in this country, and in spite of the passage of hundreds of years, they remain in an exceptionally good state of preservation.

Watercolors on silk support are very difficult to renovate. The first method to try is the *dry technique.* Draftsman's cleaning powder or art gum powder sprinkled over the painting can be brushed over with a very soft cloth, using a delicate circular motion.

A soft brush or cotton wool swab and acetone may help to remove deeply imbedded dirt or stains, but water or water-based solutions have no place in the renovation of watercolors on fabrics.

Egg tempera on canvas support can be found in many Russian and Eastern European paintings. The ground, prepared from a mixture of vegetable matter, mostly rye flower and chestnut glue, provides a sufficient base for supporting egg tempera and offers good stability. Paintings executed in this manner can be renovated with a weak solution of alcohol or ethereal hydrogen peroxide solution.

It is essential to test the solution first, which is usually done on the edge of the painting.

Some modern egg tempera paintings on canvas display flaking paint and bubbles. This is the result of the painter employing an improper ground which provides a weak binding for the tempera.

Oil paint on canvas is usually applied either very thinly in the form of turpentine washes, or in heavy, thick layers, sometimes with not enough time allowed for drying between layers.

At the beginning of the nineteenth century, bitumen transparent pigments were produced and used mostly in portrait paintings executed in England and the United States. These pigments in time produced textures like crocodile skin; the material never dried properly, and it bubbles and lifts off the ground. This type of painting becomes a problem for the restorer.

The basic ingredients used for the renovation of oil paintings are acetone, benzene and alcohol based solutions, and very weak mixtures of bleach, detergent and ammonia. The last three are extremely dangerous to paint and canvas and should be used only by experienced professionals.

The removal of surface dirt may be carried out with a soft brush, swab or cotton wool, always with a jar of turpentine standing by to arrest any paint which may be dissolving under the solvent action. The cleaning operation must be conducted without applying pressure or rubbing to the surface which is being renovated; pressure would only force the dirt into the paint cracks, from which it would be difficult to remove. The medium for renovating the oil paint should remain on top of the paint without penetrating the ground and canvas.

Some restorers perform the cleaning operation with the painting in a vertical position; some like it to be horizontally placed. This is a matter of convenience; however, during any renovation or repair operations, whatever the position of the painting, the back of the canvas must always be well supported to minimize damage and reduce strain due to any excessive pressures which may be applied. When working on a canvas which is attached to a stretcher, a thin, stiff and flat strip of plastic board should be inserted along the edges of the stretcher to separate it from the canvas and to offer some protection.

When the preliminary surface renovation is completed, all necessary repairs to the canvas can be undertaken, the missing paint areas inpainted and, if necessary, the canvas reattached to the stretcher. A coat of retouch varnish should be applied to the surface because only then do the full values of the colors, as well as surface imperfections, become apparent. When this is dry, some of the copal painting medium should be rubbed into the varnished area to allow the inpainted areas to dry with the same gloss as the rest of the surface. Inpainting should be carried out in the strongest possible light to enable the new colors to be matched to the old. (For more on inpainting, see pp. 113–115.)

Varnish is usually applied over paintings executed on canvas to act as a protective layer for oil-painted surfaces. The final coat of varnish should not be applied until nine months after the completion of the painting; by that time the paint, ground and canvas tension will stabilize. However, some painters hurried to make the painting look good and applied varnish over a surface which was not absolutely dry; the applied varnish then dissolved some of the paint and the whole area dried out, producing discoloration. In the areas of dark paint, this discoloration is not very noticeable, but light areas are difficult; as the varnish has to be removed from the paint to expose the true color of the paint, the solution used must be capable of dissolving the varnish without having any effect on the paint.

WOODEN SUPPORT. Watercolor paintings on wood panels are very popular in every country of the world. Seldom is any ground applied to these panels; rather, the paint is applied directly to the panel surface. The watercolor may consist of a solution of water and arabic gum mixed with pigments obtained from nature.

Another paint popular today in Spain, Japan and amongst primitive tribes is animal or human blood mixed with arabic gum solution to which various other natural ingredients are added.

Several paintings dated in the 1700s, painted with watercolor on olive and cedar panels, have been restored recently. The condition of the paint was excellent, as became apparent when layers of grime and dirt were removed from the surface.

Acetone and ether on small cotton swabs, rolled over the painted areas, will remove most of the dirt.

Egg tempera on wood panels can be found in India and Persia in the form of paintings and other decorative art. The well-known

Indian miniatures and Hindu portraits were painted with the help of egg and natural pigments on wood panels. These panels were sealed against moisture and display a good state of preservation.

Due to Indian cooking habits and the practice of eating with the hands, the egg tempera paintings are usually covered with grease and smoke. This coating is relatively easy to remove with benzene and acetone, which do not affect the media or pigments used.

Some of these paintings are covered with flyspecks, which form a chemical compound that is very hard to remove. Scraping with a scalpel is the only remedy.

During the period between 1500 to 1800 a number of oil paintings were executed on wood panels because, at that time, wood panel was considered the most stable and solid support for oil paint. In general a great deal of attention was given to the sealing, preservation and proper ground preparation of these panels, and today one can find them in an excellent state of repair.

Accumulated dirt on both sides of wood panels comes from open fires, kitchen vapors, cigar and tobacco smoke, dust and pollen in the air; all this added to high humidity forms a thin film over varnish and paint, and some of the ingredients penetrate deep into the paint layer. So long as the solvent used does not affect the paint and the liquid belongs to a fast-evaporating family, no harm will be done to the painting.

Paintings executed with a very thin layer of paint and then varnished present some difficulties in renovation. There is always some varnish penetration into the top layer of wood, and this top layer will be affected by the solvent used in its removal. The old, dark varnish which remains deep in the wood grain will remain there forever and discolor the paint.

To remove the top varnish layer, only fast-evaporating liquids can be recommended, and they have to be worked on one small area at a time. The flooding of panels with a cleaning liquid should be avoided as any soaking of the wood will result in the paint lifting and flaking.

PAPER SUPPORT. Media employed when painting on paper are watercolor, egg tempera, pastel, oil and acrylic.

Watercolor paintings on paper sustain a lot of damage when the surface is unprotected, due to changes in humidity, dust, water,

handling and exposure to light. Watercolors stored for a long time in damp places also become ideal food for mould.

Any work on or with paper involves long hours and some risk. Renovation can be accomplished by wet or dry techniques. If the surface of the paper is dirty and covered with dust and smoke deposit, a draftsman's powder, often referred to as *art gum powder*, should be sprinkled lightly over the painting and rubbed gently with a soft rag over the whole surface. This method will remove the accumulation of surface dirt. Small areas of dirt accumulation can be eliminated with the help of a sharply pointed pencil eraser.

Water stains will require the use of bleaching products; this is a risky process requiring a great deal of experience. Sodium hypochlorite, a chlorinated soda, is the most generally used bleach for removing stains, mildew and foxing. Bleach may be applied over the stain, in full sunlight, sprayed over larger areas, or the whole painting may be immersed in a bath of bleach solution. These procedures sound and look simple, but require a lot of practice before satisfactory results are achieved.

A much safer and simpler method of stain removal is by the use of chloride gas, which can be applied directly over the previously wetted area of the stain.

The stains most frequently found on paper and art work executed on paper products are due to:

 1. *Flyspecks*—which can be removed with a mixture of peroxide and ether.
 2. *Tea and coffee stains*—removable with potassium perborate applied over previously wetted stain areas.
 3. *Oil and grease stains*—which can be eliminated with acetone, benzene, ethyl acetate or carbon tetrachloride.
 4. *Wax and grease*—removable with gasoline and alcohol.
 5. *Ink stains*—although difficult, they can be removed by applying sodium formaldehyde sulphoxylate powder over the water-dampened stain area.

The generally used bleaching agents are:

1. *Chloramine T*—for discolored paper.
2. *Chlorine gas*—for working on small areas.
3. *Hydrogen peroxide*—for darkened and discolored areas.

4. *Sodium hypochlorite* — for stains and water marks.
5. *Ammonium hydroxide mixed with acetone* — for removing oil stains.

As an antibleaching solution, sodium thiosulfate or sodium hyposulfate can be applied.

Egg tempera is a water-soluble medium, and the only solutions which can be used to renovate it are the very fast evaporating liquids, applied on one very small area of the painting at a time. The use of bleach is not recommended as bleach has a tendency to attack egg particles, which results in decomposition of the tempera and spotty effects. Some areas are fugitive, and tests should be conducted first to see how much wetting by one of the solutions these areas can withstand before any reaction takes place.

With egg tempera and gouache surfaces which have no varnish coating, the first attempt at renovation should always be by the dry method. This will require the use of bread crumbs, kneaded eraser or drawing-cleaning powder. When applying these substances, the surface of the painting is rubbed with a finger, very gently, and all dirty powder removed with a soft brush; this operation is repeated several times.

Varnished surfaces can be cleaned with a soft rag or cotton wool swabs dampened in a mixture of five parts turpentine to one part Copaiba balsam.

Pastel and chalk paintings on paper are very fragile due to the very light adhesion of powder to the support. Most pastel and chalk art is covered by a very thin layer of fixative. Any cleaning attempts will disturb this film and expose the powder. Restoration of this type of fragile art can be undertaken only by a dry method. Paper damage, stains or discoloration can be treated only by building up new layers of pastel, so covering the damaged area.

Oil paintings on paper or cardboard were very popular at the end of the nineteenth century. In many cases the oil paint was applied directly onto paper as a very thin layer. Most of the oil was gradually absorbed by the paper, and only pigment was left on the surface. The paintings were varnished with a heavy medium, resulting in fine crackling, darkening and varnish decomposition.

Ether and acetone are the only solutions recommended for renovation of oil paintings support. Any form of alcohol should be

avoided as the relatively slow action of alcohol may dissolve the oil paint, which can then penetrate into the fibers of the support.

The use of turpentine while working with paper supports, or when inpainting them, cannot be recommended; it penetrates deep into the support and produces stains. It may also dissolve particles of paint and discolor big paint areas.

Watercolors, prints and lithographs are, even today, being covered with varnish with the idea of preserving the surface. In time, this varnish darkens, becomes brittle, deteriorates and occasionally stains the surface.

Varnish removal from artwork on paper products is a very delicate work. Using acetone or ether may affect watercolors or water-based inks, and they may dissolve or be bleached by these solvents; every piece of paper requiring varnish removal has to be individually tested, to establish the correct solution and method of treatment. This operation requires patience, a light touch when cleaning the surface and constant observation of the swab, so that at any sign of paint being picked up, one may immediately arrest the dissolving action.

Once again, it has to be stressed that any renovation of paintings executed on paper requires an extensive knowledge of chemistry, methods of paper construction and fabrication and much experience in its handling, pressing out and repair. This is beyond the scope of this book, and beyond any inexperienced restorer.

METAL PANELS. Metal plates used as supports for paintings in the past display very elaborate anticorrosion preparations. Analysis of materials used and of plates themselves shows that the surface of both sides of the panel was thoroughly prepared and all dirt and rust were eliminated. For priming, a mixture of boiled linseed oil and red lead was used, which offered good drying and covering properties as well as good elasticity.

Linseed oil varnish was used extensively in Europe during the seventeenth century. This mixture, when applied to painting, dries very slowly, but when hard it will prevent the oil paint layer from blistering and cracking.

Some sixteenth century metal panels produced in England were covered first with asphalt varnish. This was made from asphalt dissolved in linseed oil varnish, and it reacted badly with the

pigments used at that time. The result was the formation of wide cracks all over the surface of the painting.

In China, India and Persia, metal panels were covered with a ground consisting of lardite, steatite and agalmatolite, which were employed mainly as rust protection. Lardite is exceedingly fine-grained, which renders it valuable for use on metal objects. Ground steatite is one of the finest materials produced; no other material will adhere so quickly and firmly to the metal surfaces. Steatite, a soapstone, can be found in Switzerland and was used on Italian, Austrian and German paintings.

Some other forms of ground found on metal panels consist of linseed oil boiled with peroxide of manganese, turpentine, benzol, carbonate of calcium, and lead oxide. These were applied as several coating layers.

For oil painting on metal panels, two techniques were used in the past; one involved direct application of paint to the panel, and the other required application of ground first and then paint.

The basic elements of the oil paint used were linseed oil, turpentine, alcohol and pigments. The panel material was usually steel, copper, zinc or aluminum. There is very little chemical reaction between these elements and oil paint.

When paint is applied directly to a panel, it may flake off when completely dry due to lack of cohesion. It is always advisable to cover the panel first with a layer of soft varnish, to isolate it from the paint and to provide a base to which the oil paint will adhere easily.

Removal of varnish from paintings on metal panels does not present much of a problem. In most cases the panel has been provided with a good ground and the paint is on a very stable support.

The solution to be tried should be based on pure acetone or alcohol, diluted and mixed with turpentine or xylene. When removing the varnish, the ground layer should be constantly observed so that no solvent liquid is allowed to reach it.

Frames

Most renovation work associated with frames will be in connection with simple wood frames—stained, painted or finished with gold leaf.

All dust, grime and grease must first be thoroughly cleaned off with a soft brush and soft rag. The surface coating can then be renovated.

Stained or varnished wood frames should have an application of wax products. If required, an appropriate stain with color-matching substances can be added, but no oil paints should be mixed with the wax.

Painted frames will require a light application of turpentine varnish when fresh wood is exposed, and then inpainting.

Gilded articles and gold-leaf mouldings may require a complete renovation; for this the following can be recommended:

1. For spot and stain removal: hot glycerine.
2. For gilded frames: 5 parts alcohol, 1 part ammonia; or sprinkle on some whiting and rub in with vinegar.
3. For gold mouldings: 3 parts bicarbonate of soda, 1½ parts chloride of lime, 1½ parts cooking salt, 20 parts water; or 20 parts sodium bicarbonate, 1 part chlorinated lime, 1 part common salt, 15 parts water.

Inpainting damaged areas with gold paints is not recommended as they change color very quickly and darken and become flat in appearance. "Rub-and-buff" gold paste metallic finishes available on the market may be used to cover missing gold-leaf areas.

Inpainting

Preservation of continuity, and reduction and elimination of imperfections of the surface, are the main objects of inpainting. Such imperfections can sometimes be left untouched, toned down, or hidden completely. Each individual painting introduces its own problems, but the basic rules of inpainting are to keep it to a minimum and to provide a product which will be appropriate to the design and condition of the painting.

The degree of inpainting carried out depends on the extent of the imperfection. Inpainting can be done with the same color as the surrounding paint, with different values of the same color, or by

broken color that blends the lost paint in a composite color but differs from it in pattern. If the surrounding paint has defects such as crackle or abrasion, these should be imitated in the inpainting.

The inpaint must be consistent throughout the painting, limited to the damaged areas, and never extend over the original paint. It should be easy to remove, stable in structure and color, adhere well to the surface, and be similar to the original in texture, transparency, gloss and color range.

•*Inpainting Media.* On the basis of visual examination of previously inpainted areas and careful scanning of added layers of new paint concealing repairs, cracks and old paint imperfections, it is obvious that any inpainting done with oil-based paint will not continue to blend with the painting as time goes by. Due to aging, the new paint darkens, certain color areas change, and these patches disturb the general appearance. Oil paint is therefore useless for inpainting.

A great deal has been written about the composition of paint to be chosen for inpainting. Certain "secret" formulas have been devised by some restorers to provide an ideal medium, but to no avail; the paint applied still darkens with time.

The only easily removable paint media suitable for inpainting are watercolor, gum arabic, wax resin, and egg tempera.

While inpainting with watercolor paints, some water emulsion of polyvinyl acetate can be added to improve adhesion and drying time. When the area is dry, it should be coated by brushing with butyl methacrylate dissolved in a solvent.

Pastel crayons can also be used, but the pastel should be infused with size and coated with varnish.

Wax diluted with mineral spirits and mixed with pigments forms one of the most permanent inpainting media. To make it more glossy, a drop of thinned damar varnish can be added. However, an important, if unfortunate, rule is that the more ingredients one uses in the preparation of media, the more trouble one can expect.

•*Duplicaton of Color.* Needless to say, this is some of the most laborious work facing the restorer.

One of the basic requirements for color matching is a strong, diffused, white light. Another is a good selection of test samples

prepared to discover errors, as comparing colors is much easier over a large test area than over a small spot.

The gloss characteristic of the chosen paint should match the gloss of the original paint because dull, flat colors become much darker if it is necessary to apply a glossy varnish over them.

During the mixing of colors the least number of individual pigments should be used. Any color can be duplicated by using only four basic colors: white, black, and two chromatic colors.

•*Technique.* The technique of inpainting varies a lot and depends on the texture of the surface damage and the finish required.

The damaged area can be inpainted with a lighter color and glazed with transparent paint until the surrounding color is duplicated. Another method is to cover the area with dark color, scumbled with semi-opaque paint of a lighter value. Then again, the area to be inpainted may be covered with one color and stippled with one or more other colors to obtain the proper duplication.

Preparation for inpainting requires complete removal of any grease and wax from the painting; the painting must be clean and the surface dry. This can be done by careful wiping with xylene or turpentine.

The original painting usually consists of several layers of paint, and the same technique should be employed to build up the missing paint: The modeling must be gradual, not too wet, and absolutely dry before each succeeding layer is applied.

To establish tonality, earth pigments such as ochres and umbers should be used for warming tones, and blues and greys for cooler tones.

The final reconstruction of a painting by the inpainting technique includes successful elimination of the disturbing effect of damage and distortion. Talent, skill and taste usually produce a good compromise and preserve the integrity of the original painting. Self-discipline is a paramount factor in avoidance of overpainting and a good test of a restorer's capacity as an artist and craftsman.

Protection of Paintings

Most damage sustained is due to failure to protect the front and back of paintings executed on canvas, paper, wood or metal. It is unfortunate that a simple and inexpensive form of protection is often completely omitted.

Humidity, smoke and dust can really play havoc with areas exposed to the atmosphere; electrostatic phenomena will draw fine particles, suspended in the air, to the exposed surfaces, and any porous material will absorb every drop of water available in a humid atmosphere. Decomposition of varnish, paint and grounds, bacterial growth, decay of fibers in paper and wood, are all results of lack of protective measures. Fading and bleaching of colors are also caused by such neglect.

In the Norton Simon Museum in Pasadena, California, every painting displayed in the exhibition hall, be it oil paint, watercolor, pastel or pencil, and irrespective of its support — fabric, paper, wood or metal — is protected by glass. The painting itself is mounted and separated from the glass panel by one-eighth-inch-thick packing. The glass is sealed all around so that no dust can possibly penetrate. The sealing material is of a non-setting type to allow expansion and contraction of the frame and glass. All art collectors and exhibitors would do well to copy these protective measures.

The back of a painting should be covered with a sheet of corrugated cardboard, attached to the frame with wood screws. This protection is essential for every painting and will avoid its being damaged in handling, even if it is rested against sharp corners or edges of furniture when off the wall. Some restorers provide a couple of holes, covered on the inside with muslin, at the top of this protective board; these allow breathing and air flow underneath the back cover.

Health Hazards

No one knows the extent of art-related health hazards because no large-scale studies have been conducted in this field. Very few

artists and restorers are aware of the need for special precautions when working with art materials. Professionals and hobbyists may be endangered by inadequate labeling on art materials and lack of knowledge of the widespread use of toxic substances.

At present only a very few art materials contain any general warning such as "use with adequate ventilation," and none lists ingredients, health problems resulting from their misuse, or what to do in case of adverse effects.

The wording "adequate ventilation" is very misleading; few people understand that an open window will not be sufficient to eliminate fumes and vapors. To ventilate the workshop properly, fifteen air changes per hour are required. Anyone working with toxic materials needs a constant supply of fresh air, and this applies to those who spend time drawing, painting, restoring, sculpting, or working with ceramics, pottery, weaving or woodworking.

Art materials pose a special risk to children, who are more susceptible than adults to lead (used in pigments), paints containing cadmium, chromium and uranium oxide, and other toxins in art materials.

Of course we must include asbestos, as well as the arsenic found in some papers and boards, especially in gaseous form as arsine. Solvents such as benzene can be highly toxic to the nervous system, and toluene and xylene are powerful narcotics causing liver damage.

Glossary

abrasion Loss caused by rubbing.

absinthe The common wormwood.

academic painting Conservative traditional painting. Implies the utilization of the styles and techniques of the past and may be applied to any outmoded style.

accretion An accidental deposit such as a bit of wax or a layer of grime.

acetone A strong and highly volatile solvent. Available from chemical suppliers and large drug houses. *See also* **volatile thinners or solvents.**

acrylic Type of synthetic resin used in making the synthetic paints. Acrylate and methacrylate resins are made by polymerizing esters of acrylic and methacrylic acid.

acryloid A soft acrylic resin in granular state. It is dissolved in volatile thiners (q.v.) to make a paint solution.

aerial perspective A painting technique designed to convey the impression received by the eye when an object is far away and difficult to see, i.e., that a distant object is out of focus.

agglutinant Uniting as glue; causing or tending to cause adhesion. Any viscous substance which causes objects to adhere.

aggregates Inert materials such as sand, pebbles, Celite, etc., mixed with paints to obtain textures, greater viscosity or better bonds.

alkyd resins Synthetic resins used especially as surface coatings and with lacquer paints to give characteristics such as durability, non-yellowing, and flexibility.

alla prima In painting, completion of a work in one sitting with paint being applied for final effect.

altar piece A decorated screen, panel, or series of panels, movable or fixed, placed upon or at the rear of an altar.

aquarelle Traditional, transparent watercolor painting.

Aqua-Tec Acrylic emulsion paint line produced in jars and plastic squeeze bottles and available at art supply stores.

aquatint A printing technique in which powdered rosin is applied

to a metal plate, the plate is heated, and the uncovered part of the metal is etched with acid to produce grainy light and dark masses of various gradations. The plate is cleaned, warmed, inked, wiped, and printed onto paper with a special roller press to produce the aquatint.

aqueous media Any painting media with a water base.

aqueous synthetic media Water-base synthetic media which dry through the evaporation of water and become impervious to water. *See also* **polymer emulsion.**

asbestine A type of talc (hydrated magnesium silicate) used to give body to synthetics. It is an inert, fibrous pigment and will give a matt quality to gloss paints as well as slightly tint them.

asymmetric A kind of informal balance in which a large element, such as a tree, on one side of a compostion is balanced against a number of smaller elements on the other side.

attaching The application of a layer of paint or support material to the back of a picture.

auxiliary support A secondary support (q.v.).

backing Attaching a secondary support (q.v.).

bas-relief Low raised sculpture relief.

beeswax The wax secreted by bees and of which the honeycomb is constructed.

binders Anything which causes cohesion in loosely assembled substances. The agglutinant (q.v.) used to cause pigments to cohere.

birdlime A viscous adhesive made from holly bark, used for snaring small birds.

blanching A white appearance in an old surface coating or paint layer, usually caused by solvent action.

bleaching Lightening the color of darkened paper or paint.

bleeding The spreading of paint or of the colorant in the paint to another material or layer.

blemish A defect that changes the appearance of the design and that cannot be corrected; for example, a loss or a burn.

blender A round, rather soft brush, blunt or flat on the end, which is used for blending the colors or smoothing the surface of the paint by effacing the marks left by the hairs or bristles of other brushes. Blenders are usually made of the hair of the badger and are commonly called *Badger-hair blenders.* The end should not be completely flat but slightly convex.

blister A convexity or bulge in the paint surface over an area of cleavage (q.v.).

blond copal resin Presumably Zanzibar copal.

bloom A white or cloudy appearance in an old surface coating caused by the scattering of light from minute pores or cracks.

blush A white or cloudy appearance in an new surface coating usually caused by moisture that has condensed within the coating.

break A separation.

bristle brush A brush made from bristles, or the short stiff hair of swine, as distinguished from the brushes made from soft hairs or fur of the badger, calf, sable, camel, etc.

bronze spatula *See* spatula.

buckling A bending or ridging of the paint surface over an area of cleavage (q.v.).

buon' fresco True fresco. That is to say, paintings or mural decorations executed by the classic process in which the pigment is applied without a binder and simply mixed with water so that it penetrates the wet plaster and is held by the chemical action of the lime present in this substance, which is converted by the action of the air into a carbonate and acts as a binder.

butanol A blending agent to use with vinyl acetate solution paints. *See also* **vinyl acetate.**

button A small piece of wood glued to the back of a wooden panel, usually over a check to prevent its development.

Byzantine painting The term employed loosely to describe various historical phenomena of the Christian Epoch in the Eastern Mediterranean.

calcium carbonate (whiting) An inert pigment used to give body and viscosity to synthetic paints as well as oil paints. Paris White is the best grade. It tints the colors and should be used by the artist only, not by manufacturers of synthetic paints.

carbitol A volatile retarder to slow down the drying time of resin solutions, especially vinyl acetate (q.v.).

carborundum A hard abrasive, usually black in color, and useful in its powdered or granular state as a textural additive to the synthetic paints and as a surface material for producing gray masses in collagraphy prints. Available from large building supply stores, industrial suppliers and, in some cases, from pigment suppliers.

casein Refined curd of milk which is a strong adhesive. In casein tube colors, a solution of casein in water is emulsified with various gums or oils, different with each manufacturer. Casein is too brittle to use alone as a paint binder.

cast A facing of which the internal surface follows that of the paint, and of which the external surface is a plane. Its purpose is to protect the conformation of the paint during the treatment of the support.

catalysis Acceleration of a reaction produced by the presence of a substance, called the *catalytic agent* or *catalyser*, which itself appears to remain unchanged; contact action.

cauterium An instrument or appartus used for the application of heat to paintings executed in a wax vehicle.

celite A type of diatomaceous earth (q.v.) available through large paint stores or building suppliers.

cellosize A chemical thickener to use with polyvinyl acetate (q.v.) emulsions to give more body and viscosity to the medium.

cerd From the Greek meaning wax.

ceronis A commercially prepared wax varnish, similar to several American brands.

cerotic acid A white wax obtained from beeswax or carnauba wax.

cerotype A process of engraving in which the design is cut on a wax-coated metal plate.

chassis The French term for stretcher (q.v.). The wooden frame upon which the canvas is stretched tautly for painting. Stretchers should be equipped with *keys,* or little wooden wedges in the four corners, which permit tightening of the canvas when necessary by driving them in with a hammer and thus spreading the frame.

check A partial separation in a wooden support.

chiaroscuro The arrangement or treatment of the light and dark areas in a work of art to produce a harmonious effect.

chondrin A substance obtained from cartilage; the chief ingredient is gelatin.

chromic acid A very dangerous and corrosive solution made up as follows:

92 grams of sodium dichromate dihydrate
800 c.c. of pure sulphuric acid
458 c.c. of water
The solution is most effective when used warm or hot.

cleaning Taking off surface coatings, repaint, accretions, and discolorations from the front of a picture.

cleat A piece of wood or metal attached to a stiff support to hold it flat.

cleavage A division parallel to the surface in the paint, ground, or support, or between two of these layers.

coating A layer of paint; also, the process of applying a transparent film to the front of a picture.

codex Used to describe handwritten books or manuscripts made up of separate leaves and thereby distinguished from the earlier scrolls or *rotuli. See also* **rotulus.**

collage A composition pasted together of materials such as paper, cloth, wood, found materials, etc., usually of contrasting texture and pattern.

collagraph A print produced from a plate made by collage methods.

colle de Flandres *See* **colle de peau.**

colle de peau A glue made from the skins of animals. It is current in France where it is known as *totin, colle de peau,* and *colle de Flandres.* In practice in England or America any good joiner's glue may be substituted for it; or any of the liquid glues which are sold in bottles under trade names. The glue made from parchment scraps may also be advantageously substituted for colle de peau.

collotype A method of reproducing pictures in color or black and white through the use of gelatin plates.

colocynth An herbaceous vine, *Citrullus colocynthis*, allied to the watermelon. A powerful cathartic is prepared from its fruit.

colophane resins Probably refers to elemi resin (q.v.), allied to colophane resin, which comes from the *Canarium mauritianum*, on the island of Mauritius.

color perspective The effect obtained by using colder colors for the more distant objects represented in the painting.

colorant A coloring material, either a pigment or a dye.

compensation Treatment that is intended to recreate the original appearance of the design in a defect that cannot be corrected; compensation consists of filling (q.v.) and inpainting (q.v.).

complementary A color which completes, strengthens or brightens another.

complex Composed of two or more kinds of materials or elements.

complex facing One that consists of two or more layers of facing material, with two or more kinds of adhesive; for example, a layer of paper affixed with synthetic resin, and a layer of paper affixed with paste. *See also* **facing**.

complex support One that consists of two or more layers, and of at least two kinds of support material; for example, a fabric and a wooden stretcher. *See also* **support**.

complex surface coating One that consists of two or more layers, and of at least two kinds of coating material; for example, a layer of polyvinyl acetate (q.v.) and a layer of wax. *See also* **surface coating**.

composite support One that consists of two or more pieces of the same kind of support material placed side by side; for example, a panel composed of strips of wood, each attached to the adjacent strips with wax. *See also* **support**.

compound Consisting of two or more layers of the same kind of material.

compound facing One that consists of two or more layers of facing material, each affixed with the same adhesive; for example, two or more layers of paper, each affixed with paste. *See also* **facing**.

compound support One that consists of two or more layers of the same kind of support material; for example, a piece of paper mounted on cardboard. *See also* **support**.

conformation The relief of the front of a picture.

contrapposto Refers to the painting or carving of the human body so that the upper portion moves or twists in one direction and the lower in an opposite direction.

conversation piece A type of English eighteenth century painting in which family groups are shown against the background of their properties.

copaiba balsam An oleoresin obtained from several tropical trees and used in varnishes and lacquers.

copal resin A hard, natural resin that has become fossilized and is

insoluble. It is fused at high temperatures so that it can be dissolved in oils and thinners to make painting mediums and varnishes.

copolymer A polymer (q.v.) made by chemically combining different classes of monomers. For use in an artist's paint this should be a chemical combination of acrylic and vinyl monomers, and the term "copolymer" has that meaning in this book. Just mixing acrylic and polyvinyl polymers together does not produce a copolymer, only a mixture.

The use of "copolymer," as applied by some to the polymer made from various acrylic monomers, is not the accepted meaning in the trade. The word "copolymer" has no virtue whatever in itself, can mean any combination of any kind of monomers having no relation to suitability for use in artist's paints.

Coptic painting Basically, the expressive style of the autonomous Egyptian Coptic church containing many pagan elements both pharaonic and Greco-Roman.

"cornu" patent palette A palette with a lid of raffia which could be damped down to keep the colors moist overnight.

corrosive sublimate Mercuric chloride.

crack A separation in any layer of a picture.

crackle (craquelure) A network of cracks in the surface coating, paint, or ground.

cradle A secondary support for a wooden panel, consisting of one series of strips glued to the panel parallel to its grain and provided with slots through which run a second series of strips perpendicular to the first. The second series is not attached to the first series nor to the panel. A cradle is intended to prevent the panel from warping without restricting its lateral expansion and contraction.

craquelure *See* **crackle.**

crazing *See* **crackle.**

crosshatching A kind of shading produced by intersection of two or more series of parallel lines.

Cryla An acrylic emulsion paint line produced in tubes by the English firm of Rowney.

cumene (cumol) A solvent, propyl isobenzene.

cumol *See* **cumene.**

cupping Concavity of the islands of paint.

cyanine blue Phthalocyanine blue.

dahlia paper Litmus paper (q.v.) can be used instead.

damar A natural gum from a tree grown in the Malay States, bought in crystals and dissolved in turpentine (or purchased already dissolved) to make a picture varnish for oil paintings. It is a soft resin, as opposed to copal, a hard resin (q.v.). Source: art supply stores.

Darex Everflex G An industrial polyvinyl acetate (q.v.) emulsion produced by W.R. Grace & Co., Dewey and Almy Chemical Divison, Cambridge 40, Mass., and 225 Allwood Road, Clifton, N.J., and available through their distributors.

defect of plane Deformation, a change from the original conformation.

deformation *See* **defect of plane.**

denatured alcohol A type of ethyl alcohol, commonly sold in drug stores, which can be used to increase the gloss of polyvinyl acetate (q.v.) paint films.

design The pattern of colors on the front of a picture.

diatomaceous earth An inert clay of light, fluffy, absorbent nature used to give body and decrease gloss in synthetic emulsions and solutions. One of the best inert fillers for this purpose. Source: pigment suppliers.

diptych A two-paneled altar piece on hinges, usually portable, in form of painting, sculpture, ivory, enamel or metal.

disinfectant A substance that destroys microorganisms.

distemper A painting media used by Egyptians and Greeks. It is a mixture of powdered color and size.

dowel A pin of wood or metal that joins the edges of two boards, or of the separated pieces of a single board.

drawing A form of representation, generally with pencil or pen, but also in crayon or charcoal, or with brush as in oriental art.

drier *See* **siccative.**

drypoint A type of graphic art in which the lines of the design are scratched directly on the copper plate, as distinguished from etching method in which the lines are etched or bitten into the plate by acid. *See also* **etching.**

Du Pont super retarder A retarder for use with lacquers to produce a slower drying time. Available at large paint stores and through industrial suppliers of Du Pont products.

easel painting A portable kind of painting done on an upright easel and made for relatively small wall spaces, distinguished from the fixed or permanent large wall paintings known as murals.

egg tempera The purest unadulterated medium, made of egg yolk mixed with water.

egyptian painting Paintings expressed with the figures presenting the eye in full face, shoulders generally frontal, profile feet invariably flat to the ground line. The paintings were done in tempera on various grounds.

elemi resin A fragrant oleoresin obtained from various tropical trees, used in making varnishes. *See also* **gluten.**

emulsions Liquid preparations in which the minute particles remain in suspension, as the fat globules do in milk. They are intimate combinations of the elements—a physical as opposed to a chemical combination. As a rule the union of an oily and non-oily liquid is obtained through the presence of an alkaline or mucilaginous substance.

enamel A process of applying glassy material to a metallic background, usually by fusion.

encaustic Pigments mixed with heated, flowing wax as a medium, painted onto a support and, when dry, fused with a hot "iron."

engraving A graphic technique involving cutting lines on a metal plate, polishing the cut areas, inking the plate and printing.

essence *See* **solvent**.

essence of aspic Oil of spike lavender.

essence of camphor Spirits of camphor.

essence of turpentine Turpentine, pure gum spirits or steam distilled. *See also* **Turpentine**.

essential oil Solvent, distilled from various resins.

etching A printing process in which a metal plate is coated with a wax or varnish ground, lines are scratched into the ground and the plate is immersed in an acid bath which bites or "etches" the exposed lines. The plate is then cleaned, inked, wiped, and printed onto paper with a special roller press to produce the etching.

Eterna A synthetic emulsion paint line produced by Casa del Arte, Independencia, 101-C, Mexico City. It is not available in the United States.

ethyl silicate A mural painting medium based on an organic compound of silicon. Chemical reactions change the liquid to pure silica. Ethyl silicate has to be exactly formulated by the artist.

ethylated hydrocarbon Any of several alcohols.

ex-voto A kind of image in painting or sculpture that is designed to give thanks to God for past favors.

facing The process applying paper or fabric to the front of a picture; also, the structure so applied.

facing adhesive The adhesive used to affix paper or fabric to the front of a picture.

facing material The paper or fabric affixed to the front of a picture.

fantastic art A type of art in which wild, unrestrained or subconscious motivation is the image.

fat drying oil Sun-thickened linseed oil (q.v.).

Fayum portraits From a Province Fayum in Egypt, where idealized masks were placed on mummy cases and painted in encaustic (q.v.) on wooden panels or linen shrouds.

feeding Infusing paint. *See also* **infusing**.

figurative A term used to denote the degree of representational form evident in a particular work.

filling Inserting material into a hole, crack, or cavity of a picture; also, the material that fills a hole, crack, or cavity.

fixative A liquid which, sprayed or otherwise applied to a drawing, pastel, or painting in a water medium, acts as a binding agent, fixing or making the work permanent by causing the color to adhere firmly to the surface to which it has been applied.

flaking The loss of small islands of paint.

flattening Recovering the original conformation (q.v.). The deformation corrected may lie in the support, or in the ground and paint.

fluoro-veloxes Commercial art reproduction technique using fluorescent liquids for washes of black to gray which are photographed by a fluorescent screen camera.

folk art Type of art created by untrained people in all parts of the world.

foreshortening A technical device in drawing or painting in which the artist simulates the projection of an arm or leg out of the picture plane toward the spectator.

forgery Imitation made with the intention of deceiving as to authorship, origin, date, age, period, school.

foxing Small, scattered brown stains in a paper support.

framework Stretchers.

fresco Consists of painting into a surface of freshly spread, wet plaster with water-mixed pigments. *Fresco secco* is painting onto a dry plaster wall, which has been wet with lime water, using pigments ground into an aqueous medium such as casein or the polymer emulsions. The term *fresco secco* may also be applied to any painting done on a dry plaster area. *See also* **buon' fresco.**

frottage Placing a sheet of paper on the surface of the object and running a stick of graphite over it to bring out the grain or other characteristics.

gel medium A thick, viscous polymer emulsion medium which dries clear. This term has been applied also to a complete variety of gelled mediums for oil painting, completely unsuitable for use with synthetic emulsions. Be sure that the medium discussed is designated for oil or water media to avoid confusion and painting problems.

general Affecting the entire picture, as opposed to local.

general cleaning Cleaning of the entire picture. *See also* **cleaning.**

general facing A facing that covers the entire picture. *See also* **facing.**

general secondary support One that reinforces the entire picture; for example, a relining. *See also* **secondary support.**

genre Applies to works with all kinds of subject matter, specifically to subjects taken from everyday life.

gesso Plaster of Paris or gypsum, especially as prepared for use in painting, by the extension of a plasterlike or pasty material upon a surface to prepare it for painting or gilding. *Gesso duro,* "hard gesso," is a variation of the original formula of plaster and glue or chalk and glue which makes a harder gesso. *Gesso sottile,* "fine gesso," is prepared with slaked plaster. *Gesso grosso,* "coarse gesso," is less carefully prepared and used for the under or first coats; prepared with unslaked plaster.

Synthetic gessos are ready-to-use liquid ground paints which have a polymer emulsion binder and can be used on any support, are flexible

and non-yellowing. Synthetic gessos dry and can be painted over with any medium within 30 minutes.

Glauber's salts Sodium sulphate, gluten elemi, elemi resin.

glaze Transparent film of paint made by mixing a small amount of color with a large quantity of medium.

gloss medium Paint medium which dries to a highly reflective, shiny surface. "Polymer medium" and "gloss medium" are the terms used in the synthetic emulsion lines.

gluten (also Taubenheim's, elemi) Preparation consisting of a wax and a resin dissolved in an essence of turpentine, spike, petrol, etc.

gouache A method of painting with opaque colors which have been ground in water and mingled or tempered with a preparation of gum. More loosely, a watercolor in which white is employed as a paint or pigment, by contrast with the method of attaining the whites necessary by allowing the paper to show through, or by transparency. All pigments are used in an opaque manner as opposed to traditional transparent watercolor (aquarelle).

grain alcohol Ethyl alcohol.

grained paper Paper with tooth (q.v.).

granular Of paint structure, consisting entirely or almost entirely of pigment particles, with little or no vehicle.

graphic arts This term applies to work which is predominantly linear in effect, and to the various print processes such as etching, drypoint, engraving, lithograph and woodcut.

grime A granular accretion.

grisaille A monochromatic or one-colored painting usually in gray for easel painting or stained glass.

gross-grained paper Rough-surfaced paper.

ground The prepared surface upon which a painting is executed; including a size (q.v.) and priming (q.v.), which are applied to the support to give a tighter surface, and a tooth (q.v.), to decrease absorbency or to increase luminosity. Grounds are not usually necessary for synthetic media unless special qualities are desired.

gum resins The coagulated juices and saps of various plants and trees consisting of a mixture of a gum with a resin. Gum resins are, in accordance with their composition, partially soluble in alcohol and partially in spirits of wine. Sarcocolla is an example of a typical gum resin.

haarlem siccative A magnesium drier.

hao A literary familiar or studio name used by authors and painters in China, indicating a change of residence, a special event or a characteristic quality.

Harrison red Toluidine red.

hatching An arrangement of groups of parallel lines so close together as to form areas of shading, producing light/dark effects.

highlight A spot of bright light or high value on an object; the illusion of reflection cast by a light scource.

hog's-hair brush A stiff-bristled brush.

housepainter's knife A putty knife or a flat scraper.

hue The property of light by which the color of an object is classified in reference to the spectrum. It may be characterized by its value, which is the amount of light and dark it contains; or by intensity, the amount of gray with which it is saturated.

hydrate A compound formed by the union of water with some other substance and represented as actually containing water.

hydrate of baryta Barium hydroxide.

hydrofluo-silicic acid Hydrofluosilicic or fluosilicic acid.

Hyplar A copolymer (q.v.) emulsion paint line produced in jars and cans and available at art supply stores.

hypochlorite of potash Potassium hypochlorite.

icon An image or painting representing the Virgin Mary or a saint or holy character painted or sculpted to a fixed or conventional representation or symbolism.

iconoclast Signifies anyone who destroys an idol, whether artistic or ideological.

imbibing Being infused with a coating material. A porous paint or support material that is accidentally infused with coating material when the picture is coated is said to have imbibed the coating material.

impasto Broadly speaking, the surface of a painting; the layer of paint as laid on the canvas or panel; hence the handling or manner of painting peculiar to an artist. In a narrower sense, any particularly thick or heavy application of paint.

impregnating Infusing.

inert pigments (clay) Fine, powdery substances which do not tint or appreciably change the color of a paint when mixed with the paint for purposes of thickening or matting. Among the useful inerts are asbestine, calcium carbonate, diatomaceous earth, Celite, marble dust, pumice, silica, talc. If used to excess by paint manufacturers they can become cheapeners or adulterants, but they also impart desirable qualities in specific cases.

industrial polymer emulsions As referred to in this book: polymer emulsion (q.v.) produced for the industrial trade as basic media for house paints, industrial coatings, glues, and fine arts paints. They are unpigmented and at times require many additives to form a paint. Included are acrylics, polyvinyl acetates and copolymers (all q.v.).

infusing Introducing coating material into the voids of a porous paint, ground layer, or support.

inpainting Applying paint to blemishes to make them inconspicuous; also, the paint applied to blemishes.

kakemond A Japanese hanging scroll usually mounted on paper faced with silk damask with rolls at each end.

key the little wooden wedge inserted in the inside corner of the wooden frame or stretcher on which the canvas is stretched.

lacquer (Traditional:) A painting medium derived from the sap of the sumac tree found in Japan, China and the Himalayas. It dries to a hard gloss finish. Also a shellac solution made from the resinous substance secreted by a scale insect native to India. (Synthetic:) Very quick drying media and paints produced chemically for industrial coatings and automobile finishes, which have the same hard gloss finish of traditional lacquers. Their various ingredients of cellulose compounds, synthetic resins, plasticizers, etc., are dissolved in volatile thinners and solvents.

lacquer thinner A volatile thinner used to thin or dissolve lacquers. Available at most paint stores.

landscape A painting, print or drawing of a given scene in nature.

Le Page's glue Hide glue.

lean (of paint structure) Characterized by a predominance of pigment particles over vehicle, but without the extreme imbalance characteristic of granular paint.

lean to fat A painting term which is applied to oil painting, describing the rule wherein paints with least oil content (lean) should be applied before paints that contain a larger amount of (fat). If this rule is not followed in oil painting, the paint film will crack.

ley *See* **lye.**

limner A folk painter during colonial period of republican America. A two-dimensional kind of painting, generally anonymous.

linear A kind of painting emphasizing contours.

linear perspective Means of simulating the third dimension on a two-dimensional surface by means of lines that converge as they move away from the spectator.

liner A brush made of long hairs used for drawing lines.

lining A secondary support that is continuously attached to a fabric or paper primary support with an adhesive; also, attaching such a support. *See also* **secondary support.**

linseed oil A highly purified drying oil, pressed from the seed of the flax plant and used as the medium for oil paints. Available at all art supply stores.

Liquitex An acrylic polymer emulsion paint line produced in jars and in tubes. *See also* **polymer emulsion.**

litmus paper Unsized paper saturated with litmus; used in testing for acids or alkalis.

local Affecting only part of the picture, as opposed to general.

local cleaning Taking off repaint, coatings, and accretions from only part of the picture; for example, from the light colors.

local facing A facing (q.v.) that covers only part of the picture.

local secondary support One that strengthens or supports only a specific area of the primary support; for example, a patch. *See also* **secondary support.**

long oil varnish Any resin varnish containing a high percentage of oil.

Lucite An acrylic resin produced by E.I. Du Pont de Nemours and Co., Wilmington, Delaware. The resin can be dissolved in volatile thinners to produce a paint medium.

lunette A curved or rounded window or wall space.

luting Filling losses or cracks in the ground or paint layers; also, a filling in the ground or paint layers.

Luzitron An acrylic resin solution sold as a paint medium and varnish.

lye (ley) A highly concentrated aqueous solution of potassium hydroxide or sodium hydroxide.

magna An acrylic resin solution paint line, pigmented and sold in standard artist tubes by Bocour Artists Colors, 552 West 52d St., New York, New York, and available at art supply stores.

makimond A horizontal scroll painting that is intended to be seen while sitting at a low table.

manna The sweet exudate of the European flowering ash, *Franinus ornus,* which is used as a mild laxative.

marouflage A French term for the method of gluing a canvas uniformly and smoothly to a wall or panel.

Masonite A commercial, pressed fiber-board available at building suppliers. Tempered Masonite has a hard finish; untempered, a soft finish.

mastic A variety of resin used in making varnish.

matiere The surface of a painting consisting of the applied paint with particular reference to its inherent beauty or quality.

matte medium A painting medium which dries to a flat, non-glare finish.

matte varnish A final varnish which will not cloud over dark colors and which dries flat. It may also be used as a medium.

mechanical cleaning Taking off surface coatings, repaint, or accretions by brushing, fracturing, cutting, abrading, or scraping with an instrument.

medium The basic liquid binder into which powdered pigments are ground to make a paint. A vehicle. (Plural: media.) Various media may be used with and added to a paint to modify its properties.

megilp A preparation used usually in watercolor (q.v.) and gouache (q.v.) painting for mixing with the colors to retard their drying or facilitate their application.

mending Affixing the edges of a separation in a support; for example, the gluing together of the two pieces of a split panel.

methyl isobutyl ketone A highly toxic solvent used to dissolve and thin some of the synthetic paint resins and solutions. Available at chemical suppliers.

methylated spirit Methyl alcohol.

methylene chloroform Ordinary chloroform.

mezzotint Printing technique in which carborundum is rubbed

between two copper plates to create a rough grain on the copper. The rough copper is polished (burnished) with a piece of steel to create white areas of the design when the plate is inked, wiped, and printed; rough areas produce soft gradations of black to gray.

migration of plasticizer Some of the synthetics (notably the polyvinyls) require chemicals ccalled *plasticizers* to make them flexible. Many of these plasticizers are deficient in that they sink into the support upon which the paint is applied, or they evaporate. This process in which the plasticizer leaves the paint film is called *migration;* the paint is left brittle as a result. The length of time a plasticizer takes to migrate varies.

mineral spirits A volatile thinner used to thin oils and some of the synthetic resins. It is a rectified petroleum product, varies in quality from brand to brand, and dries somewhat faster than turpentine.

miniature A small size painting; a portrait medallion.

modeling The attempt to give a third dimension to a particular form by means of light and dark effects by crosshatching or color relationship.

modeling paste In relation to the polymer emulsions (q.v.), a product made by adding marble dust and other inert material to the polymer medium, producing a heavy bodied "paste" which can be used for impasto and modeling and sculptural techniques.

moisture barrier A layer applied either to the front or to the back of a picture to reduce the rate of moisture exchange between the picture and the atmosphere. A moisture barrier may consist of a coating, a sealing layer, or a secondary support such as a layer of sheet cork.

monochromatic Employing one hue or a color scheme based on the various tints of that one hue or color.

monomer The thin, volatile, relatively simple molecular chemcial units which are polymerized into non-volatile, solid, and extremely stable polymers. *See also* **polymer.**

monoprint A print taken from a surface which will produce only one print copy. A water-base paint is usually painted onto a repellent surface (such as glass) and paper is placed over the design to make the print.

mosaic painting Bits of colored material are embedded in plaster or other adhesives to make up the design or to form the figures.

motif A theme or dominant feature of a painting.

mount A stiff secondary support (q.v.) of heavy paper, cardboard, composition board, etc.

mounting Attaching a stiff secondary support (q.v.).

murals Paintings executed on or applied directly to walls.

nacconal NRSF A wetting agent which helps the dispersion of pigments in aqueous media.

naturalism An art of reproducing in a precise manner the appearance of objects in nature.

New Masters A copolymer (q.v.) emulsion paint line packaged in plastic tubes and bottles.

nitrocellulose Cellulose fiber which has been nitrated by drastic treatment with nitric acid. It is soluble in certain organic solvents, and, with modification with flexiblizing plasticizers and with various resins, it makes the well-known nitrocellulose lacquers (known also as *pyroxylin lacquers*). While nitrocellulose lacquers are tough and relatively durable for moderate periods of time, their nitrated structure will eventually cause film disintegration.

nourishing Infusing paint. *See also* **infusing.**

opaque Non-transparent; impervious to the rays of light.

operation A single step in the treatment of a picture; for example, brushing paste on the front of a picture is an operation in the facing process.

organic solvents Chemical liquids that are compounds of carbon. They are solvents for (i.,e., they dissolve) resins and nitrocellulose. The term usually applies to the stronger or more active solvents such as acetone, tuluol, xylene, ethyl acetate, butanol, methyl isobutyl ketone, etc., rather than the more common and weaker organic solvents such as turpentine and mineral spirits.

overcleaning Taking off original paint during cleaning.

overpaint Repaint that covers original paint.

oxidation A chemical action in which a material combines with oxygen. Oils dry by the process of oxidation, a chemical drying process.

oxide (oxyde) A binary compound of oxygen with an element or radical; as iron oxide.

paint A thin coating composed of a vehicle, pigment particles in a vehicle, or pigment particles alone; also, the material from which such a coating is made.

palette A broad and flat object of wood, metal, glass, china, porcelain or similar material used by the painter for laying out and mixing his colors; also, the set or assortment of colors chosen or preferred by a particular artist or used in a particular method of painting.

palette knife A thin and flexible knife used for mixing and application of paint.

palmitate of aluminum The stabilizer most commonly used in the United States is aluminum stearate.

panel A stiff primary or secondary support of wood, metal, etc. *See also* **support.**

paper cast One in which the transition from the irregular conformation of the paint to the flat conformation of the cast is made by molding a piece of blotting paper.

papier-mâché A construction or material made by mixing a binder with paper pulp or paper cuttings.

papiers colles A technique of pasting bits of non-painted materials into a pictorial design.

partial cleaning Taking off the material that overlies the design to a limited depth only; for example, taking off a varnish surface coating

without taking off the repaint and oil film that lie between the varnish and the paint.

passe-partout A method of framing or putting drawings or watercolors under glass in which a band of cloth or gummed paper takes the place of the usual frame.

paste (1) an adhesive, usually made with starch; (2) a filling material, made of an adhesive such as wax or resin and an inert material such as whiting or kaolin; (3) of paint structure, characterized by an equilibrium between the vehicle and the particles, that is, neither lean nor rich.

pastel A stick of dried paste made of pigments ground with chalk and mixed with gum water.

pastel painting A technique of applying chalk, crayon or pastel to a flat surface.

pastiche A technique where many different or divergent styles are used.

patch A piece of fabric or paper that is attached to the back of a support in an area of weakness.

patent knotting A commercially made sealing compound, or "sealer."

pattypan Muffin tin.

pellicle Skin.

pellicular Of paint structure, consisting entirely or almost entirely of vehicle, with few or no pigment particles.

Perlite Expanded mica. A very lightweight material which can be used for textural additives in paint. It is obtainable at building suppliers.

perspective A technique of painting which simulates depth or three-dimensionality on a two-dimensional surface.

petrol Petroleum spirit such as is used for producing motive power in automobiles. Gasoline.

Pettenkofer method Re-forming a surface coating by exposure to solvent vapor; the method is named for its inventor, a celebrated German chemist.

picture An object, usually flat, with a design on one surface.

pigment A dry, powdery substance which imparts its color to a medium but which is not dissolved in the medium. Pigments may be either derived from natural sources or produced chemically (synthetically).

plane A successive stage of depth within a painting.

plastic cast One in which the transition from the irregular conformation of the paint to the flat conformation of the cast is made by molding a plastic material.

plasticizers Substances which are added to a medium to maintain necessary flexibility or to correct undesirable brittleness.

Plexiglas Acrylic plastic manufactured by Rohm & Haas, Inc., Philadelphia, Penn.

Politec An acrylic emulsion paint produced in jars.

polychrome Painting executed in many or various colors.

polyesters A class of synthetic resins which frequently are cast in situ at normal temperatures, activated by a small percentage of catalyst. The catalyst is usually volatile and highly toxic.

polymer A compound formed by chemically uniting a number of like molecules into larger molecules and thereby changing the physical properties of the basic compounds (monomers) without altering their essential compositions. Volatile monomers are polymerized into non-volatile and extremely stable polymers.

polymer cement A sculptural medium made by mixing polymer emulsion with cement and other additives.

polymer emulsion A water suspension of a synthetic resin to form a paint medium which can suspend pigments in a liquid state, and, upon drying, keep the pigment dispersed as well as protected. "Synthetic emulsion" and "polymer tempera" are terms used to mean the same thing.

polymer tempera The polymer emulsion (q.v.) medium developed by Alfred Duca. This medium is a polyvinyl acetate (q.v.) emulsion and has to be formulated by the artist; it is not available on the market. It was the first commercial polymer emulsion produced for the artist.

polymerization The process by which a polymer (q.v.) is made.

polyptych A many-paneled altar piece (q.v.) where individual panels are folded or hinged.

polyvinyl acetate (PVA) A plastic resin of the vinyl family which requires a plasticizer to make it flexible. Vinyl acetate is polymerized by adding peroxides and heating to yield polyvinyl acetate emulsions. *See also* **plasticizer, polymer.**

polyvinyl acetate emulsion 953-7 A (Polyco 953-7 A) A PVA emulsion manufactured by the Borden Co., Chemical Division, Foster St., Peabody, Mass. This is the PVA used to make polymer tempera (q.v.).

primary hues In practice of painting, red, yellow and blue.

primary support The layer that bears the ground or paint film directly.

priming A coating of white paint (usually white lead) applied to a sized canvas to provide a base for painting as well as for a reflective surface in oil painting. The priming can also be one of synthetic emulsion gesso. The oil priming should not be painted over for four weeks after its application; the synthetic priming can be painted over with oils as soon as it is dry (about thirty minutes). A size must be used with oil priming. No size is required with synthetic priming.

process In restoration work, a series of operations intended to alter, remove, or apply a specific structural element.

profile board Plywood.

psycho-prismatism The affective psychology of color. The study of the reactions of human beings or animals to the various colors.

pumice Powdered, volcanic-type rock used for polishing materials

and for textural additives in painting and collagraphy. Available at large building suppliers, some paint and pigment suppliers.

purified linseed oil Called sun-thickened linseed oil in the United States. *See also* **linseed oil.**

putting down Reattaching.

pyroxylin *See* **nitrocellulose.**

rainwater Distilled water can be substituted.

realism An expression when an artist provides a convincing portrayal of a given form, bypassing the minute details usually associated with a photographic image.

reattaching Affixing the separated surfaces in an area of cleavage.

re-forming (regenerating) Swelling a coating with solvent.

regenerating *See* **reforming.**

relining Attaching a fabric with an adhesive to the back of a fabric support; also, the fabric so attached.

removing Taking off material, that is, a ground or support layer, from the back of a picture.

repaint Paint applied in the treatment of a picture; repaint includes both inpainting (q.v.) and overpaint (q.v.).

resin An organic substance exuded from plants or trees which can be dissolved in volatile solvents to produce a paint medium or varnish which is transparent and water resistant. Resins may be hard or soft, recent (extracted from living trees) or fossil (those dug from the earth, such as copal). Synthetic resins are substances which have properties similar to those of natural resins, but which are made by chemical processes, such as the plastic resins discussed in this book.

resin solution A resin dissolved in a volatile thinner or organic solvent. Resin solutions are not compatible with water or aqueous media.

Resoflex (RO296) An excellent plasticizer (q.v.) and the only one to be used in the formulation of polymer tempera (q.v.). Resoflex RO-296 is a product of Cambridge Industries, Cambridge, Mass.

restoration An attempt by various means and processes to restore to an old or damaged painting its original freshness of color and appearance.

restrainer An inactive liquid that is mixed with a solvent to dilute it and thus to slow its activity on a coating.

retarder A liquid that is mixed with a solvent to reduce its rate of evaporation.

retouching Repaint or repainting.

Rhoplex AC 33 and AC 34 Types of acrylic emulsions produced by Rohm and Haas Co., Philadelphia, Penn.

rich Of paint structure, characterized by a predominance of vehicle over pigment particles, but without the extreme imbalance characteristic of pellicular (q.v.) paint.

rigger A long-haired brush with a flat end for making lines or bands of various thicknesses.

rinse A liquid that is used to carry away accretions (q.v.), or to carry away a solvent or detergent and the substances it has loosened.

rip A separation at a seam in a fabric support.

rotulus A handwritten scroll.

Russian icon The earliest religious panel painting of orthodox artists.

sable brush A brush made with the fur or hair of the sable.

sarcocolla A gum resin not easily available in the United States.

Scotch glue A find hide glue.

scumble A layer of light, semi-opaque paint applied to darker paint.

seal (sealing layer) A layer of paint applied to the back and edges of a picture.

sealing Applying a layer of paint to the back and edges of a picture, usually to protect it from moisture.

sealing layer *See* **seal.**

secondary hues Refers to the colors used by traditional artists, orange, green and violet.

secondary support A support layer that reinforces the primary support (q.v.); for example, a relining fabric and a stretcher are both secondary supports for a fabric primary support.

separation A division perpendicular to the surface in a layer or series of layers; for example, a crack, tear, or split.

serigraph A fine art, silk-screen process in which designs are made on silk. Color is scraped over the design with a squeegee so the color will print through areas of the silk which have not been blocked out. The technique is a multi-color, multi-screen process which resembles gouache painting. The effects achieved can be very subtle and varied.

setting (setting down) Reattaching.

sfumato Light, smoky shadows which soften the face (cheeks, throat) of a portrait.

sgraffito A method of mural decoration by which a dark surface which has been covered with a coat of lighter color is allowed to reappear in the form of lines by scratching away the light-colored coating.

shading A combination of light and dark tones providing a three-dimensional appearance.

Shiva acrylic An acrylic emulsion paint line produced in tubes by Shiva.

siccative (drier) A preparation used to hasten or promote the drying of paints.

siccative de courtrai A manganese oxide drier.

silhouette An outline or profile of a given form against another form; a portrait cutout against a lighter background.

silica White or colorless and extremely hard silicon dioxides; the principal constituent of sand, quartz, etc. Silicates referred to in this book are the crystalline, inert pigments with little or no tinting strength used to give body or impart tooth to a medium.

silicate A salt or ester of any of the silicic acids.

silicate of soda Sodium silicate in water solution, commonly called *water-glass.*

silicon esters Volatile liquid, organic compounds of silica, among which is ethyl silicate.

silverpoint A drawing technique which uses a piece of silver to draw on a coated paper to produce a pale, delicate gray line. The Old Masters used this technique and coated their papers with a thin colored ground of powdered bone, mixed with gum water. Today the coating can be synthetic emulsion gesso (see **gesso**).

simple Consisting of a single layer or material.

simple facing A facing (q.v.) that consists of a single layer of adhesive and a single layer of material; for example, a piece of paper affixed with paste.

simple support A support (q.v.) that consists of a single layer; for example, a piece of paper.

simple surface coating A surface coating (q.v.) that consists of a single kind of coating material; for example, a layer of wax.

simultaneity A design or painting showing different aspects of the same form at once.

size A coating given to raw canvas before the priming. It protects the canvas from the harmful effects of the oil paints and gives the canvas a heavier body. An animal glue (or glue gelatine) is used for this purpose.

skin glue Hide glue.

skinning Taking off original paint during cleaning.

solution media Painting media made by dissolving resins in volatile thinners.

solvent Liquid capable of dissolving another substance.

spackling compound A plaster-like compound used to patch cracked masonry, plaster, murals, etc., and which can be used to create impasto surfaces when mixed with the polymer emulsions (q.v.). Source: paint stores and building suppliers.

spatula An implement shaped like a knife, flat, thin and somewhat flexible, used for spreading paints, fine plasters, etc.

split A complete separation in a rigid support (q.v.) such as a wooden panel, that is, a separation that divides the support into two pieces.

stabilizer A chemical used to keep many of the synthetic emulsions in suspension.

stain An accretion (q.v.) that penetrates or combines with materials of the picture.

stand oil A thickened linseed oil (q.v.) made by heating the oil in stainless metal containers at a high temperature in the absence of oxygen. It does not yellow as much as linseed oil. Source: art supply stores.

standardization The labeling process used by leading American

manufacturers of artists' colors to identify their paints' chemical constituents.

stencil brush A very stiff-bristled brush.

stereochromy A process of wall painting in which silicate of soda is used as a vehicle and protective coating.

sterilizing Treating an object with a disinfectant.

stretcher A secondary support for fabric; it consists of a frame, usually rectangular and made of four strips of wood that are capable of being forced apart at the corners.

Styrofoam A plastic produced by the Dow Chemical Company and available at building suppliers and plastic supply houses.

subacetate of lead Basic lead acetate.

sugar of lime Calcium acetate.

sulphate A salt or ester of sulphuric acid.

sulphide A binary compound of sulphur, or one so regarded.

sulphuric ether Diethyl ether.

sun-clarified linseed oil *See* **sun-thickened linseed oil.**

sun-thickened linseed oil (sun-clarified linseed oil) A thick linseed oil (q.v.) made by exposing the oil in shallow pans to the sun. This process gradually thickens the oil, bleaches it and gives it faster drying properties. It is the best and fastest drying of the oils and does not yellow as much as linseed oil; it flows better and gives brighter and more transparent colors for oil painting. Source: art supply stores. Permanent Pigments, Inc., 2700 Highland Ave., Norwood, Ohio, produces the only sun-thickened oil colors available.

support The untreated object destined after preparation by the application of the ground, priming, etc., to receive the paint: cloth, canvas, a panel of wood, composition board, cardboard, paper, a wall, etc.

supporting frame A device to hold a picture upright during treatment.

surface coating (surface film) A layer or series of layers of transparent film material applied to the front of a picture.

surface film *See* **surface coating.**

synthetic emulsion *See* **polymer emulsion.**

synthetic paint A paint based on synthetic resin media, either emulsion or solution type.

T-square A straightedge with a stock attached at right angles to one end.

tactile values The contrasts or differences in the surface of the paint engendered by the manner in which it reflects the rays of light. For example, smoothly applied paint will reflect the rays of light in nearly parallel rays, giving a hard and brilliant impression; roughly applied paint will diffuse them in all directions, giving a soft and matt impression. As the qualities enter immediately into association with ideas connected with the sense of touch (roughness, velvety smoothness, etc.), the values thus arrived at are called tactile values.

tall oil Any oily resinous liquid composed of a mixture of rosin acids and fatty acids obtained from pine pulp.

tannin Tannic acid.

tapestry A fabric usually of worsted worked on a warp of linen by hand, the designs being usually pictorial; also, a fabric of the same nature dyed or painted by a method which colors without obscuring the weave or filling the interstices between the threads, in which case it is usually qualified as a *painted tapestry.*

Taubenheim's *See* **gluten.**

tear A separation in a fabric or paper support.

tempera A method of painting in which the pigments are mixed or tempered with an emulsion, or the yolk or white of eggs, as distinguished from those methods which use glues, gums, oils, etc. Egg tempera is the method by which the colors are mixed with yolk of egg and varying proportions of water.

tempered Mixed or blended, or modified.

tetra-chlor-ethan Tetrachloroethane.

Tibetan painting Usually by monks in the form of a hanging scroll or banner on cloth and faced with silk, protraying the life of Buddha with colors prescribed by law where each color has its symbolic meaning.

tingeing power Tinting power.

toluene (toluol) A volatile solvent. Source: large paint stores and chemical suppliers.

tonality A painting technique giving predominance of one hue or color.

tooth Roughness of surface fitting it for the application of paint which will be held in place by the minute variations and irregularities afforded by such a surface.

torrefied common salt Non-iodized table salt.

totin *See* **colle de peau.**

transferring Replacing the support (q.v.) of a picture, and occasionally the ground (q.v.) as well.

treatment The altering or taking off of present substances, or the applying of new ones, to prevent deterioration and to correct or compensate for that which has already occurred.

trecento Italian art of the thirteenth and fourteenth century.

triptych A three-paneled, hinged and portable altar piece (q.v.) in the form of a painting or sculpture in ivory, enamel or metal.

Tri-Tec An oil-wax-casein emulsion paint which is thinned with water.

trompe l'oeil A painting that "tricks the eye," simulating the actual object to deceive the viewer.

turmeric paper Use litmus paper (q.v.).

turpentine Distilled gum of pine trees. *See also* **volatile thinners or solvents.**

underpainting The basic structure or design of a painting, which may be done broadly or in high detail, in black and white, complementary colors, etc., before the final painting or "finish" takes place.

varnish (1) a natural resin that is dissolved in a volatile solvent or in linseed oil; (2) a natural-resin surface coating. The term is sometimes used loosely to include surface coatings of other materials such as synthetic resins, or any solution or emulsion medium for coating finished paintings so they will withstand dampness, grease, dust and atmospheric as well as chemical damage. Varnishes are available in matt and gloss finishes for all media.

vehicle The medium (either traditional or synthetic) used to "carry" the pigment and other ingredients to make a paint. *See also* **binder, medium.**

venice turpentine An oil-type medium (balsam) from the European larch tree. It gives adhesion and a high gloss when mixed with oil mediums. It was used by the Old Masters as a thickening agent and for special oil recipes, but is little used today.

verism Highly disturbing clinical technique of painting. Meticulously precise, introducing horror and fright.

Vermiculite Expanded mica. A lightweight additive used for textural painting and as an aggregate (q.v.) in sculpture. Available at building suppliers.

vinyl A type of synthetic resin used to make the synthetic paints. Vinyl is usually brittle in paint formulations and requires plasticizers (q.v.).

vinyl acetate Plastic resin made by adding acetylene to acetic acid in the presence of mercury salts. There are many types of vinyl acetate and vinyl chloride acetates; most have poor adhesion properites, can be used only in (low solids content) media and are not very resistant to ultraviolet light (so that they have to be loaded with ultraviolet "absorbers" as well as plasticizers). The artist should be sure of the type he uses to avoid these handicaps as much as possible. *See also* **Vinylite (AYAF and AYAT).**

vinyl chloride acetate Copolymer resin (vinyl chloride-vinyl acetate) which comes as white fluffy powders and must be dissolved in highly volatile thinners. *See also* **vinyl acetate and Vinylite (VMCH and VYHH).**

Vinylite (AYAF and AYAT) Vinyl acetate resins produced by Union Carbide Corporation, 270 Park Ave., New York, N.Y. (Chemicals Division) and available at chemical suppliers or distributors.

Vinylite (VMCH and VYHH) Vinyl chloride acetate resins. Source: same as above.

Vinylseal A solution of vinyl acetate (dissolved in acetone) which is produced by Union Carbide Corporation.

volatile thinners or solvents Liquids that completely evaporate from the paint film and usually have pungent, characteristic odors. They are inflammable and frequently highly toxic to the human body if steadily inhaled in high concentration. Acetone, benzene, toluene, xylene and

lacquer thinners are the stronger solvents which should only be used in well ventilated areas. Turpentine and mineral spirits are volatile solvents with which all artists are well acquainted; they are low in toxicity. All are used to dissolve resins to make paint solutions or to thin mediums or paints. Available from art supply stores, paint stores, or chemical suppliers.

vorticism British school of painting (1912–1915) introducing dynamically fragmented conception of form.

wall painting A picture that has a clay, mud, or plaster primary support and has, or originally had, a wall as the secondary support.

wash A transparent application of color applied thinly, used particularly in watercolor or india-ink technique.

watercolor An aqueous medium of water and gum arabic into which powdered pigments are ground. Sometimes a plasticizer (q.v.) such as glycerin is used in the paint.

water-glass *See* **silicate of soda.**

wetting agent A chemical used in paints to help pigments become "wet" or easily dispersed and ground into the medium.

white ground vase painting A three-dimensional art with naturalistic detail, distinguished by strong geometric patterns.

white lead Normally called *flake white* or *Gremnitz white* in the United States.

whiting *See* **calcium carbonate.**

writer A long thin brush such as is used by sign painters and showcard letterers for writing in the round.

xylene Volatile solvent. Flammable toxic isometric liquid used chiefly in the manufacture of dyes.

Bibliography

Bradley, Morton, Jr. "The Treatment of Pictures." Cambridge, England: Art Technology, 1950.

Brommelle, H.S., and Smith, Perry. "Conservation and Restoration of Pictoral Art." London: Butterworth, 1976.

Clarks, Carl D. "Pictures, Their Preservation and Restoration." Butler, Md.: Standard Arts, 1959.

Emile-Male, Gilberte. "The Restorer's Handbook of Easel Painting." New York: Van Nostrand Reinhold, 1976.

Gettens, Rutherford, and Stout, George L. "Painting Materials." New York: Dover, 1965.

Gutierrez, José, and Roukes, Nicholas. "Painting with Acrylics." New York: Watson-Guptill, 1966.

Hours, Madeleine. "Conservation and Scientific Analysis of Painting." Van Nostrand Reinhold, 1976.

Heck, Caroline K. "Handbook on the Care of Paintings." New York: Watson-Guptill, 1967.

Kelly, Francis. "Art Restoration: A Guide to the Care and Preservation of Works of Art." New York: McGraw-Hill, 1972.

Mayer, Ralph. "The Artist's Handbook of Materials and Techniques." New York: Viking, 1957.

Ruhemann, Helmut. "The Cleaning of Paintings." London: Faber & Faber, 1968.

_____. "The Cleaning of Paintings: Problems and Potentialities." Hennessey, 1968.

Sheffield, Lucy. "How to Find and Restore Your Old Paintings." Watkins Glen, N.Y.: Century House, 1972.

Thompson, Daniel V., Jr. "The Practice of Tempera Painting." New York: Dover, 1962.

Yeamans, George T. "Mounting and Preserving Pictorial Materials." Muncie, Ind.: Ball State Bookstore, 1976.

Index